CLAUDE
MONET

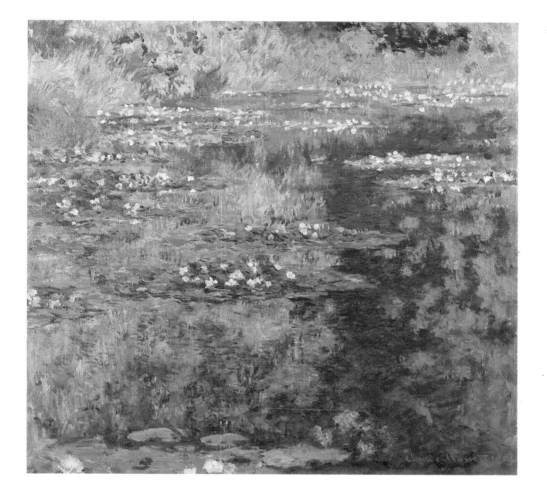

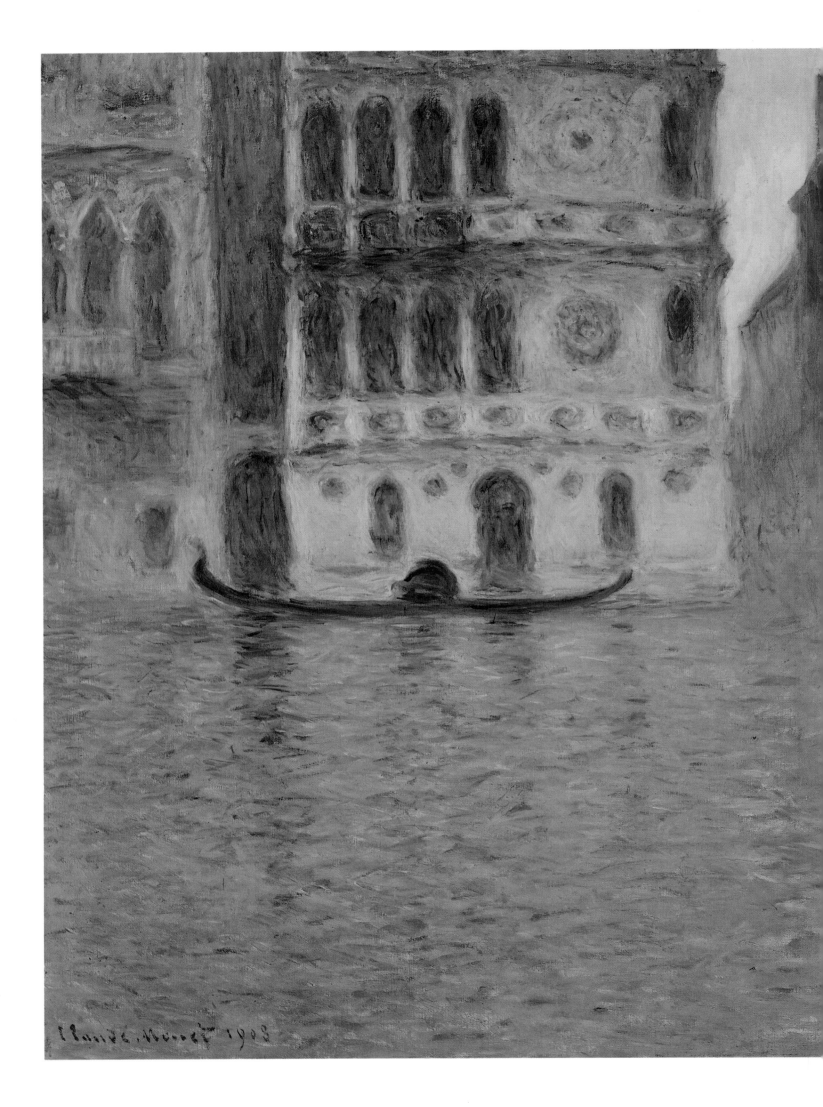

CLAUDE MONET

NANCY NUNHEAD

PARK LANE

Published by Park Lane
An Imprint of Grange Books PLC
The Grange
Grange Yard
London SE1 3AG

Produced by
Bison Books Ltd
Kimbolton House
117A Fulham Road
London SW3 6RL

ISBN 1-85627-566-3

Printed in Spain by Gráficas Estella, S.A.

The right of Nancy Nunhead to be
identified as the author has been
asserted by the same in accordance
with the Copyright, Designs and
Patents Act 1988.

PAGE 1: *Waterlilies*, 1904, Musée des
Beaux-Arts, Caen.

PAGE 2: *The Dario Palace, Venice*,
1908, National Museum of Wales,
Cardiff.

CONTENTS

INTRODUCTION

The paintings of Claude Monet are the most popular in the Western world. No artist's work is more widely disseminated, through public museums and exhibitions as well as in reproduction in posters, postcards, and more arcane media. Such blanket exposure can have a strong effect of dislocation on a work of art, depriving it of a context. A classic example of this phenomenon is Leonardo's *Mona Lisa*, a painting where the very lack of contextual information – even after years of study art historians do not know her identity and most members of the general public know little about the role of portraiture in sixteenth-century Italy – is a part of many viewers' responses to and understanding of the painting and the subject's putative 'aura of mystery.' If we take the artist's intention as a guide – always a dangerous course of action – then it is perhaps possible to understand Monet's paintings without any knowledge of their context, in that one of the main intentions expressed by the Impressionists was to capture fleeting impressions of color and light, and that is one effect that the paintings have on the viewer. It is, of course, naïve to suggest that any work of art can be purely objective; if that were the case, it would be impossible to distinguish the work of one photographer from another and photography could not be considered an art form. The potential for 'objectivitity' is further curtailed in painting. While the photographer has to make choices about types of material, subject and composition, in painting these choices are only a first step in a series of decisions made throughout the creation of the painting.

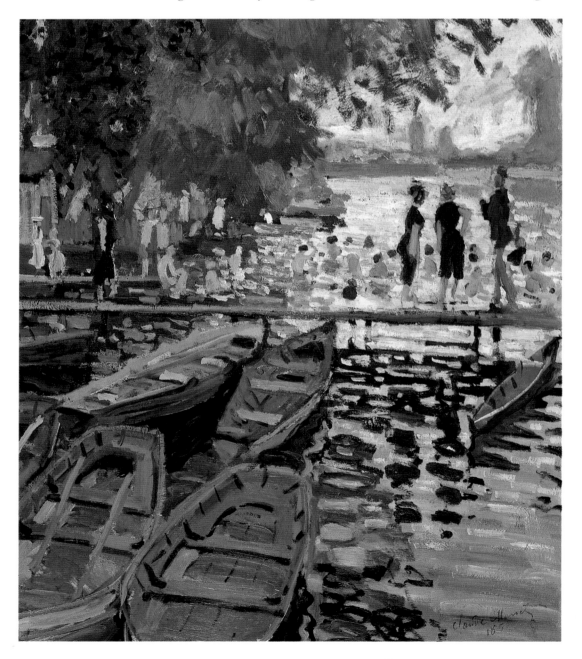

LEFT: Detail of *Bathers at La Grenouillère* (page 46), showing the animated brushwork and consistently intense color which Monet used to convey his sense of the transient effects of nature.

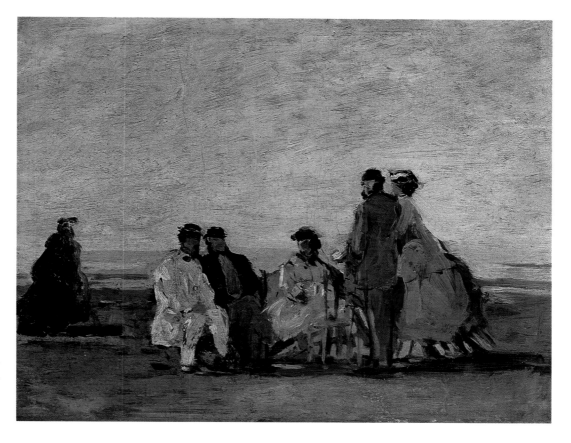

RIGHT: Eugène Boudin, *Beach Scene at Trouville*, c.1865. Boudin's small seascapes and beach scenes, recording the changing skies and scenes and the fashionable beaches of the Normandy coast, were a formative influence on the young Monet. Boudin's originality lay in his spontaneous and delicate brushwork. He exhibited at the first Impressionist exhibition, held in 1874.

all of which bear the imprint of subjective and personal choice. Bearing this in mind, we can say that, because the Impressionists' intention was to achieve an objective rendering of a 'snapshot' of light and color, in so far as they succeeded we can come closer than in almost any other kind of painting to the 'eye of the artist.'

Claude Oscar Monet was born in Paris in November 1840 but moved with his family to the Normandy port of Le Havre when he was about six. His father was a partner in a family chandlers and grocers and hoped that his son would join him in the business. Unlike many

concerned fathers, however, he did not oppose Monet's wish to pursue an artistic career. This open-mindedness may be connected to the latter's early success in accruing 2000 francs from the sale of caricatures he had drawn of local worthies, suggesting that he had a saleable talent. But more important for Monet's artistic development was his contact in Le Havre with Eugène Boudin. Monet was at first disdainful of Boudin's painting but, after watching him at work one day painting a seascape on the beach (the practice of painting in the open air was not, as is commonly held, invented by the Impressionists),

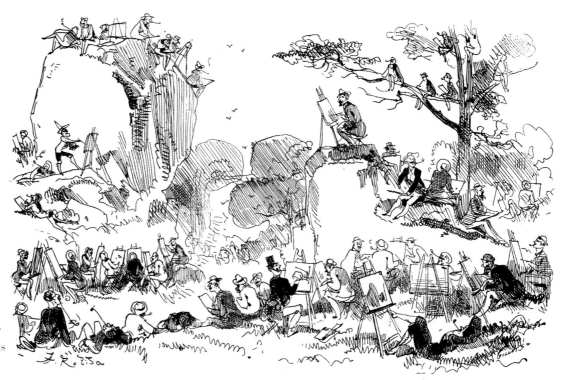

RIGHT: This caricature, which appeared in the *Journal Amusant* of 4 September 1869, gives a humorous view of *plein-air* painters at work.

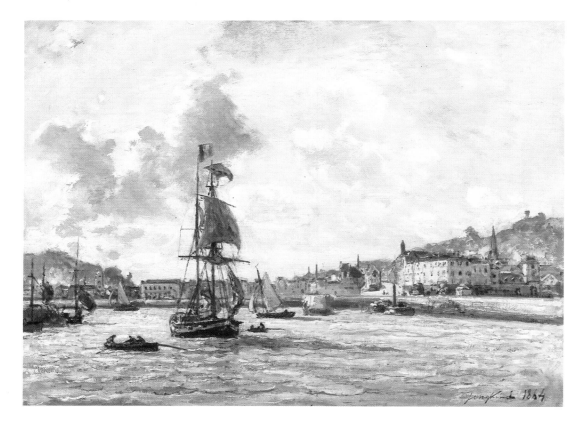

LEFT: Johann Barthold Jongkind,
*Entrance to the Port of Honfleur
(Windy Day)*, 1864. Monet met
Jongkind in 1862 in Le Havre, when
he was invalided out of the army,
and later said he owed him 'the final
education of my eye.'

FAR RIGHT: Charles Lhullier, *Le
Militaire*, 1861, shows the uniform of
the Chasseurs d'Afrique which Monet
joined in 1861.

BELOW: Gustave Courbet, *The
Painter's Studio*, 1855, an
enormously influential and
controversial painting.

and seeing his ability to capture the subtle nuances and immediacy of the commonplace scene, Monet was won over.

Boudin's influence can also perhaps be seen in Monet's choice of training when he arrived in Paris in May 1859. He chose to enrol at the Académie Suisse, an informal establishment where the students received minimal supervision and simply contributed to models' fees. Monet's father had expected him to try to enrol with the studio of Thomas Couture. Couture was a paradigm

of the success an artist could enjoy if he followed the prescribed path of training at a successful painter's studio, followed by entry to the Ecole des Beaux-Arts and exhibition at the Salon, the biennial exhibition organized by the art establishment, of which the Ecole was another important part. But Couture's huge, usually classically inspired paintings, so popular at the Salon, must have seemed stultifyingly dull to the young Monet.

A further instance of Boudin's influence may be seen in the artistic circles in which Monet moved in Paris. The

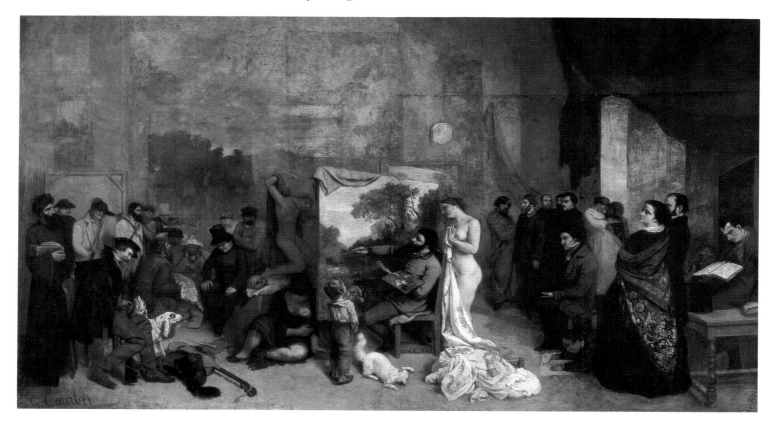

Salon of 1859 contained a number of works by painters
such as Millet, Rousseau, Corot, Daubigny, and
Jongkind, who worked together at Barbizon, a village in
the forest of Fontainebleau, south of Paris. Monet
commented approvingly on their works which, like
Boudin's, were unidealized views of unexceptional
landscapes painted in close-toned earth colors and gray.
This understated Romanticism contrasts both with the
large-scale and highly finished classicism of many of the
Salon paintings, and with the more heroic and
monumental vision of Romantics in the mold of Eugène
Delacroix.

Monet was also attracted to the company of more
radical artists, such as those who gathered around the
painter Gustave Courbet in the Brasserie des Martyrs.
Courbet's circle termed themselves Realists because,
while they followed Delacroix in using high-Romantic
devices such as a heroic celebration of the human figure,
they showed a determined acceptance of modern, urban
subject matter which was anathema to most Romantics.
Even within this group there was a division in individual
approaches to such subjects. For some there was a strong
element of social commentary, while others saw the
depiction of the lower classes as an autonomous artistic
activity, unconnected to a search for social improvement.
Monet belonged to this latter group, although his
political views were vaguely left-wing all his life.

Monet's earliest work in Paris, *Corner of a Studio*
(1861), shows little influence from these new
acquaintances. It highlights, rather, the influence which
seventeenth-century Dutch art and the French
eighteenth-century painter Chardin had on art students
such as Monet. Some disruption in Monet's studies
occurred at this time, when he was unfortunate enough
to be chosen by lottery for military service. Refusing to
allow his father to buy him out of this obligation, Monet
joined the dashing 'Chasseurs d'Afrique' and was sent to
Africa. After contracting dysentery there, Monet did
allow his father to obtain his discharge and he returned
to France to convalesce.

On his return to Paris in 1862 Monet decided to
register in the studio of the Swiss painter Charles Gleyre.
The attraction of Gleyre's studio was not so much the
work of the artist, who had been a pupil of the great
Neoclassical painter David, but the fact that it was cheap
and that Gleyre did not impose on his pupils a rigid
course of instruction for entry to the Ecole des Beaux-
Arts. Monet's arrival was to prove crucial for the history
of French art in the late nineteenth century, for it was
there he met Pierre-Auguste Renoir, Alfred Sisley and
Frédéric Bazille. These young artists spent the Easter of
1863 together at Barbizon, meeting the artists they
admired and painting in the open air. Monet's works in
this period, such as *Normandy Farmyard* and *Rue de la
Bavolle, Honfleur* remind us, particularly in their
unassuming subject matter and restricted palette, of the

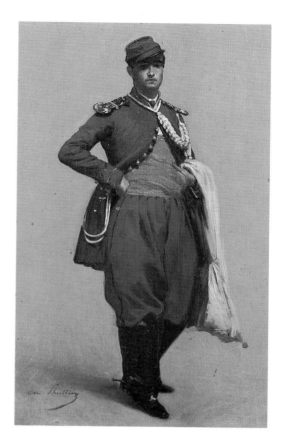

work of Corot and Millet, just as his early seascapes,
such as *La Pointe de la Hève at Low Tide*, recall
Jongkind and Monet's early mentor Boudin. If the
paintings lack some of the vibrancy of his later work,
this has much to do with the practice of reworking in the
studio paintings begun in the open air.

The year 1863 saw something of a crisis in the
Parisian art establishment. When the hanging committee
of the 1863 Salon rejected an unprecedented 4000 works
of art, Louis-Philippe ordered the setting up of a 'Salon
des Refusés' to give a platform to the rejected artists. The
Salon des Refusés was important as the first official
exposure of paintings which departed from the officially
sanctioned large-scale classical painting regarded as the
canon of French cultural life. The painting which caused
the greatest stir at the Salon des Refusés was Edouard
Manet's *Le Déjeuner sur l'Herbe*, a picnic scene of two
fully-clothed men and two naked or scantily clad
women. While the naked female form was an essential
component of the classically and historically derived
imagery of the official Salon painters, it was
unacceptable to adopt it in what was essentially a
contemporary scene. Realism was regarded as bad
enough in itself, but to subvert classical painting by
incorporating one of its chief motifs in a Realist or
Naturalist painting was an outrage to the Salon
committee.

This painting and others by Manet touched a chord
with Monet and the other young painters. They saw in it
a means for depicting everyday life, both urban and
rural, without the Romantic overtones to be found in
Courbet's Realism. Another important feature was

Manet's use in his paintings of new pictorial devices and novel spatial conventions, such as flattened perspective and close-up or 'cut-off' elements, influenced by his study of the Japanese woodblock prints then becoming popular in artistic circles in France. Manet's use of dramatic tonal contrasts which eliminated half-tones was also partly influenced by photography. The thoroughness of Manet's search for a truly new kind of art, and the *Déjeuner sur l'Herbe* in particular, inspired Monet to begin work in 1865 on a huge canvas with the same title. He had some success in having two seascapes accepted for the 1865 Salon. His aspirations in painting *Le Déjeuner sur l'Herbe* were less complex than Manet's had been: Monet sought principally to create a painting with uncompromisingly contemporary subject matter, on a scale large enough to lend it the monumentality and gravitas of more conventional Salon paintings. The subject was, once again, a picnic scene – in fact in the forest near Chailly – although Monet's figures, based on his friends, are life-size and conventionally attired. The painting was later damaged by damp and cut down in

size, but the original composition is known from a large oil study now in the Pushkin Museum, Moscow.

Although the Salon stood for many things that Monet and his contemporaries despised, nonetheless success as a painter depended on the exposure of exhibiting there. Despite Monet's own modest success at the 1865 Salon, the 1860s were generally lean years for him. His father had cut off his allowance, partly because Monet refused to marry his mistress Camille Doncieux, who gave birth to his son Jean in 1867. He became adept at borrowing money from wealthy friends such as Bazille, and in 1868 a portrait commission, *Madame Gaudibert*, from another wealthy family enabled him to set up home at Etretat on the Channel coast. Paris as a subject interested Monet, as can be seen in such works as *The Quai du Louvre* (1867). He was, however, never a true Parisian in inclination like Manet or Degas. Portrait and interior scenes still dominated his work at this period and the influence of Manet in his composition, handling of paint, and use of color is still very evident in works such as *Camille (The Green Dress)*.

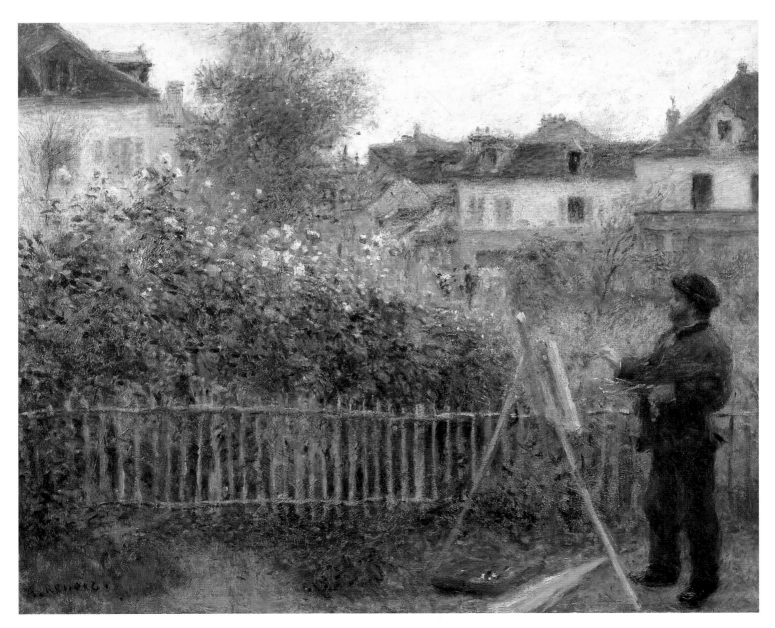

RIGHT: Edouard Manet, *Le Déjeuner sur l'Herbe*, 1863. When exhibited at the Salon des Refusés in 1863, this painting shook the Parisian art work, with its direct challenge to traditional assumptions about art, but inspired Monet and other younger artists to emulation.

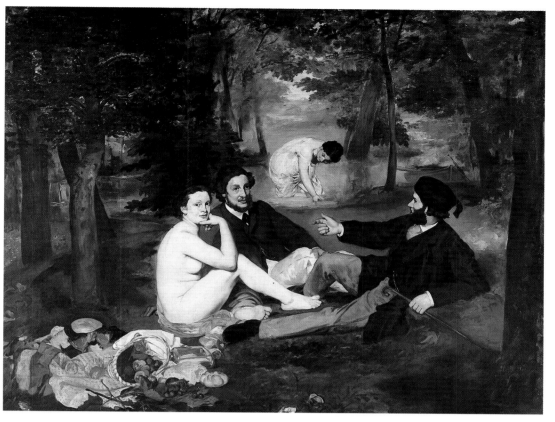

The year 1867 can be seen as a watershed in the development of Monet's artistic vision, for it was to this year that he dated his adoption of a truly impressionist technique. The term 'impressionist' is not a precise one in any sense, and was used freely in the late nineteenth century to describe almost any kind of avant-garde painting which did not belong to the classical school. Even as applied to the work shown at the great Impressionist exhibitions of 1874-86 it is imprecise. All Monet's work from 1867 to 1926, when he died, can be described as 'impressionist,' yet his art underwent several transformations both in vision and technique. The common factor with all Monet's impressionist paintings is an attempt to capture nature as it appears at any given moment and to infuse each painting with the artist's particular sensations in the face of nature. One implication of this view was that, for landscape painting to be truly impressionistic, it had to be painted from start to finish in the open air, and abandoned when the light effects changed. The series paintings of the 1890s,

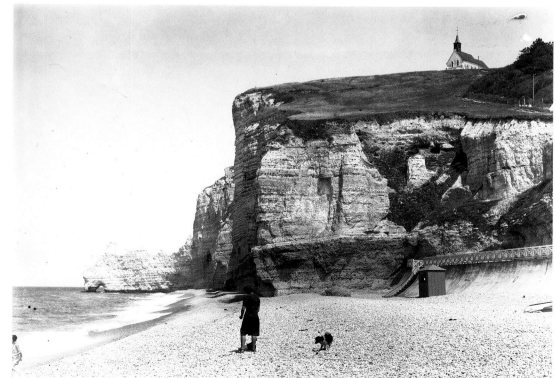

LEFT: Pierre-Auguste Renoir, *Monet Painting in His Garden at Argenteuil*, 1873. Renoir worked closely with Monet in the 1860s; this intimate portrait shows him in the garden of the house he acquired on his return from London in 1872.

RIGHT: The beach and cliffs at Etretat, a scene often painted by Monet (page 42).

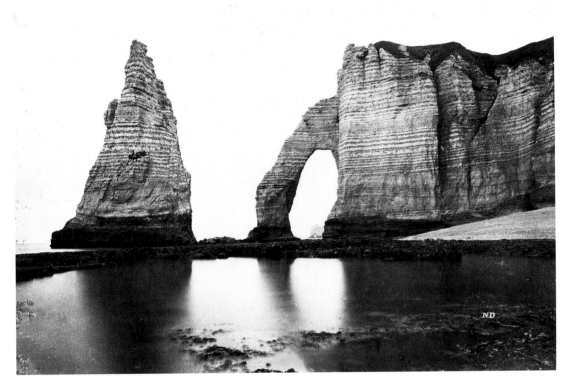

LEFT: The Needle at Etretat and La Porte d'Aval at low tide, with the Manneporte visible in the background; Monet immortalized both in *Rain, Etretat*, 1885 (page 100) and *The Manneporte*, 1886 (page 98).

especially the *Grainstacks* and *Rouen Cathedral* , were the logical result of this approach. To render correctly the effects of light came for Monet to mean painting purely in color, not in tone. The earliest of Monet's impressionistic paintings, such as *La Grenouillère* (1869), still feature black pigment for shadowed areas, but soon this use was abandoned. Black is not a constituent of any color of light; shadow was to be rendered, as it seemed it was in nature, by combinations of pure color. This can be seen to good effect in *Hôtel des Roches Noires at Trouville* (1870). In seeking in *La Grenouillère* to capture the complexities of light on water, reflected light, shadow, light through foliage, and so on, Monet, and Renoir with whom he spent time painting this scene, were pursuing their search for a new subject, as well as a new technique or a new vision in art. La Grenouillère was a bathing place on the River Seine frequented by the middle and working classes of both sexes: an appropriate subject for an artist influenced by Edouard Manet.

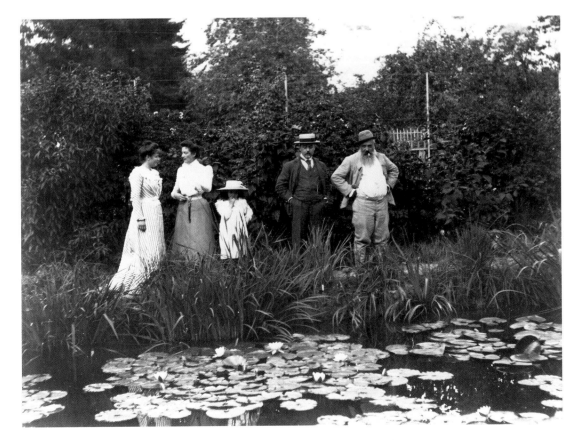

LEFT: Monet with the dealer Paul Durand-Ruel, who was instrumental in establishing his name, photographed in the garden at Giverny in September 1900.

RIGHT: The boulevard des Capucines in Paris, a city scene which Monet painted on a number of occasions (pages 72, 73).

The year 1870 once again saw Monet in danger of military service. In July France and Prussia went to war and Monet left for London with his family to avoid the call-up. It was a wise decision; his friend Bazille was killed in the war. The visit was important in introducing Monet to a city that was to become his most constant urban subject; over the years he painted more than a hundred views of the Palace of Westminster and the Thames bridges, from *The Thames and Westminster* (1871) to *London, Houses of Parliament* (1905). The interest for him perhaps lay in the subtlety of the light effects to be found in London, whose smokey atmosphere rendered even sunny days hazy. While he was in London, Monet consorted with other refugees such as Daubigny and Pissarro, visiting public galleries and exhibitions with the latter. It was probably Daubigny who effected Monet's lastingly important introduction to the dealer Paul Durand-Ruel, who showed a Monet seascape in his Bond Street gallery in January 1871.

Durand-Ruel was to remain Monet's dealer for more than 50 years, until his death in 1923, and was responsible for Monet's rise in fortune in the early 1870s, after he returned to settle with his family in the small town of Argenteuil, on the banks of the Seine six miles from Paris. By 1873 Durand-Ruel had bought paintings to the value of nearly 30,000 francs. Monet, it seems,

still managed to live beyond his means, keeping himself and Camille, to whom he was now married, in the style to which they had been accustomed all their lives. Argenteuil was the perfect setting for Monet to develop, practice, and continue to formulate his art. Although it had been completely rural until the mid-nineteenth century, suburban sprawl was beginning to reach it in the 1870s. The location thus gave Monet a choice of subject between rural harmony and social gathering, and with either he would have the complexities of light provided by the river. It was also the first time that he made a garden and used it as a subject, an activity that was to dominate his last 30 years.

The various circles of avant-garde painters and writers had, by this time, long been debating the desirability of organizing an alternative exhibition to the Salon to exhibit a varied selection of modern painting. The success of the Salon des Refusés of 1863 and of Manet's one-man show at the 1867 World Fair in Paris was encouraging, particularly to artists such as Pissarro and Cézanne, who had been consistently unsuccessful in submitting to the Salons. Bazille had strongly believed on principle that an alternative show should be held, while Manet thought that only by taking the fight to the enemy camp, that is by exhibiting new art at the Salon, would any progress be made. Monet's position seems always to

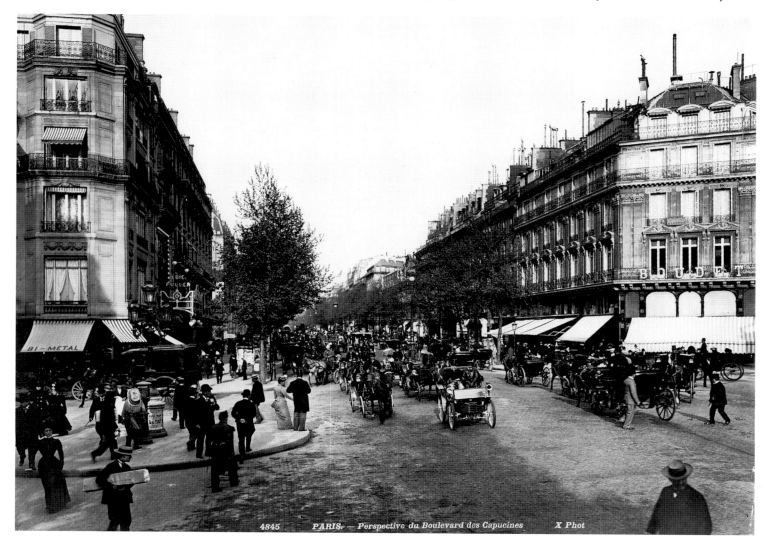

4845 PARIS. — *Perspective du Boulevard des Capucines* X Phot

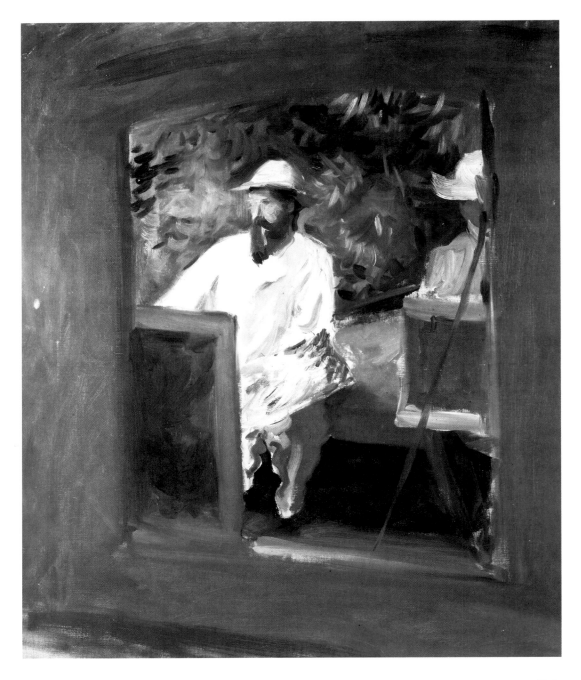

have been pragmatic. He continued to submit work to the Salon but also supported an alternative exhibition, probably because it represented a further vehicle for promoting his art.

In December 1873 15 painters, including Monet, Renoir, and Pissarro, signed a charter setting up a limited company to exhibit their work. The exhibition was held at a studio in the boulevard des Capucines which had formerly been occupied by the photographer Nadar. Monet showed five oil paintings, including a Thames view entitled *Impression: Sunrise* (1872) which led to the critic Louis Leroy coining the term 'Impressionists' as a derogatory comment on the paintings' 'lack of finish.' The show was certainly not a complete failure and attracted a considerable number of visitors. Monet was able to sell *Impression: Sunrise* for 800 francs after this, and at later Impressionist exhibitions in 1876 and 1879 many of the works he showed were listed as already sold.

An examination of Monet's paintings of the mid- and late 1870s suggests that his pictorial interests were beginning to override any concerns he had previously shared with the Naturalists with introducing a social critique or commentary, even human interest, into his art. Although his wife and son feature often in the scenes of his garden at Argenteuil they form just another element in the composition, further vehicles for his pursuit of authentic light effects and truth to nature. Even where Monet is painting pure landscape, however, his vision is perhaps not as coldly implacable as he would have us believe. His paintings of the area around Argenteuil suggest a rural idyll that is not borne out by contemporary descriptions of encroaching industry and untreated sewage fouling the Seine. Only rarely does Monet allow such concerns to impinge on his vision, as in *Railway Bridge at Argenteuil* (1874). A major exception to this rejection of industrialization, although one that was not to be repeated, is the series of eight views of the

Gare Saint-Lazare in Paris which Monet exhibited as a group at the 1877 Impressionist exhibition. But even here what has caught Monet's attention are the extraordinarily complex and fugitive effects of light in the reflexions in the glass station roof and the billowing smoke and steam. Thus it seems that it was the challenge of the subject's visual qualities which inspired Monet, and not an interest in progress through industrialization or, conversely, the condition of modern urban humanity. Indeed the figures in the painting are indistinguishable as individuals; they are reduced, as one critic put it, to 'clamor.'

Monet's continuing success through the 1870s was in part due to his willingness to adopt new types of subject if his dealer Paul Durand-Ruel suggested it. His ventures into still-life paintings were probably 'market driven.' Nonetheless he succeeded in suggesting new pictorial possibilities in the way fruit, flowers, and other inanimate objects are strewn apparently haphazardly across a surface in a quite different manner from his earlier restrained Chardinesque efforts. It was to be another 30 years or so before he followed this line of development through to its logical conclusion.

The decade 1880-90 is often seen as a period of crisis for Impressionism. Despite the differences between the several artists who exhibited at the Impressionist exhibitions, and the variety within each artist's work,

Impressionism was in danger of becoming an 'idiot eye.' Cézanne's comment on Monet that 'he is an eye but, my God, what an eye' expresses well the limitations that a contemporary found in his approach. For an artist such as Cézanne the way forward lay in structure, both in the literal structuring of his paintings' surfaces and in finding and expressing the essential structures of his subjects. For a younger artist such as Georges Seurat, who had never been an Impressionist, the answer lay in divining the scientific rules for picture-making, with paint applied in dots of pure color, and with the lines of the composition arranged according to some supposedly objective emotional qualities. Monet abhorred such an impersonal approach to art but it is ironic that in some of his seascapes of 1886-90 Seurat, with his studio-based technique, succeeded in capturing, in a much more objective way than Monet, the fleeting effects of light and reflexion.

Monet's response to this crisis in art was to seek out more complex and extreme natural effects, whether Norwegian snowscapes or the harsh, vibrant color of the French Mediterranean coast. He also began to experiment unashamedly with the composition of his landscapes. Whereas before he would tinker with parts of the composition, now he experimented with whole compositions. Unlike Manet, Monet rarely introduced

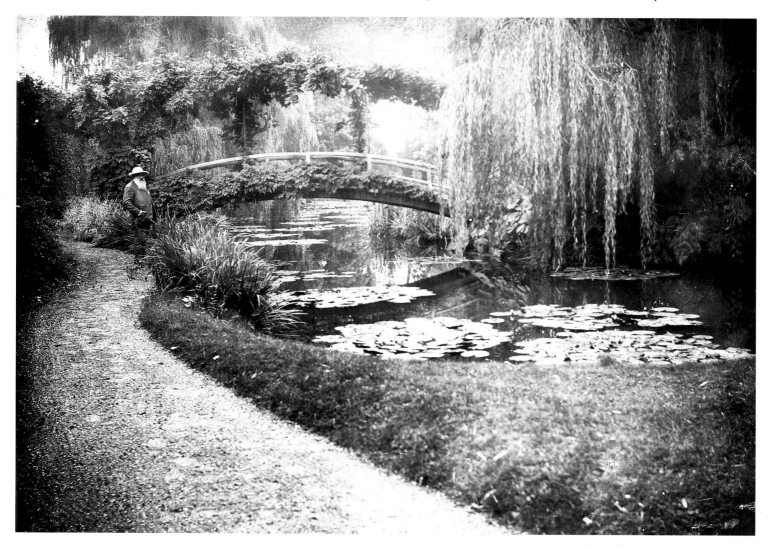

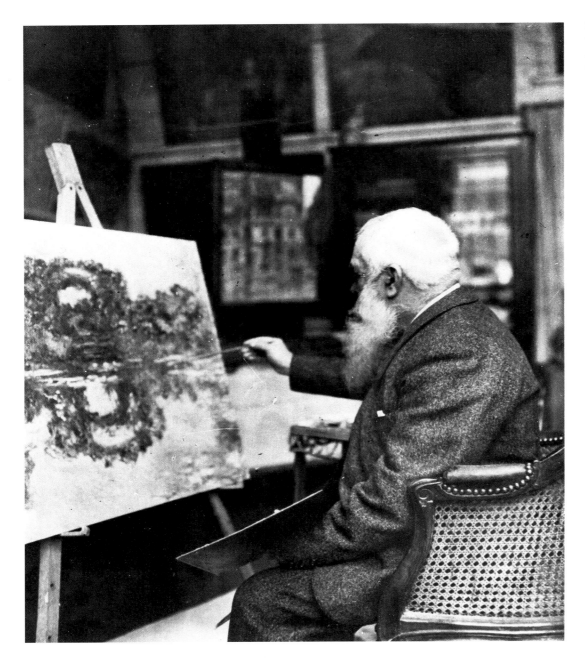

overtly Japanese motifs into his work, but his approach in the 1880s was strongly influenced by Japanese landscape print designers such as Hokusai and Hiroshige. This can be seen, for example, in the way that the tilted-up foreground mass of cliff in *Cliff at Dieppe* (1882) catapults the viewer straight into the flat, perspectiveless background of sea and sky. The application of paint is also quite different, both from the rather smooth, creamy surface of the early 1860s' paintings and from the tight-packed strokes of unbroken color of, for example, *La Grenouillère*. The brushstrokes have now become much more loose and vibrant, varying from coiling to straight within a single painting. Monet seems to be consciously seeking a dynamic and a harmony of color within his paintings which are unrelated to his response to the motif. Moreover where linear perspective has been banished as an organizational device, color seems to replace it in defining, if not conventional recession, then a sense of depth in the painting, as in *Valley of the Creuse* (1889).

Figure painting still featured in Monet's repertoire of subjects at this time. During the late 1870s he and Camille and their children had set up home with one of his patrons, Ernest Hoschedé and his wife Alice, who had fallen on hard times. Monet and Alice had formed an attachment, and after Camille's premature death in 1879 they lived together as man and wife, finally marrying in 1891 on Ernest Hoschedé's death. This complex domestic set-up provided Monet with two women and numerous children to people his garden- and river-scenes. There is still, however, an element of detachment, as in the works of the 1870s, in his treatment of the figures, which have a disconcerting habit of melting into the background, to become just another pictorial device.

The crisis in Impressionism which had dogged many painters in the 1880s found a triumphant resolution for Monet personally in the 1890s in his series paintings, the largest of which were the *Poplars*, *Grainstacks* (both 1891), and *Rouen Cathedral* (1892-4). Each series purports to represent the same subject under the varying

light conditions that prevail at various times of day and in different types of weather. In the rigor of their approach and their highly artificial color and composition, for all their supposedly objective recording of natural effects, the series paintings can be seen as a riposte to Seurat and a departure from Monet's former Impressionist practice; yet they can also appear as a linear and logical development of Impressionism. The decision repeatedly to paint the same subject can be seen as an attempt by Monet to transcend the subject, and to find some 'pure' sensation of nature and natural effects.

The development of Monet's art over the last 30 years of his life seems to confirm this view. In 1890 he bought the freehold of his home at Giverny in Normandy and proceeded to create a garden. This incorporated a Japanese-inspired lily pond, on which he was increasingly to focus as a subject for his paintings. Indeed, apart from a group of paintings of London in 1904-05 and a further series of Venice in 1912 Monet, never again ventured beyond his garden in his art. In veneration of his new motif he seems almost to have begun his artistic development again in exploring it. The earliest views, such as *The Japanese Bridge*, are quite conventionally composed, with tonal contrast and surface facture which hark back to the late 1860s. In the series of 48 works exhibited in 1909 called 'A Series of Water Landscapes', his view has drifted down from the bridge toward the surface of the water, the paint has become more dilute, but the forms of the lilypads and the reflected images are still distinct. In later years the vision of leaves, lilypads, clouds, and sky begins to dissolve, as Monet's focus descends to the surface of the water itself: the subject transcends our perception of it as the distinction between sky and water disappears.

Some artists spend their old age producing lesser work, either in quantity or in quality. The composer Sibelius, for instance, composed nothing in the last 30 years of his life, and few would disagree that the quality of Renoir's painting after 1900 deteriorated. Monet's late work must, therefore, be seen as a tremendous triumph of hope and a transcendence over the deaths of his wife in 1911 and son Jean in 1914. At the suggestion of his friend, the statesman Georges Clemenceau, Monet arranged to leave his 1914-16 waterlily paintings to the French nation. He extended the idea by painting several enormously long canvases, which came to be arranged in two circular rooms in the Orangerie in the Tuileries Gardens in Paris. They have been described as the 'Sistine Chapel of Impressionism' and represented for Monet a celebration of post-First World War peace. They can also be seen as the ultimate expression of those Impressionist ideals which Monet had been exploring for 60 years. In the prophetic words of J.M.W. Turner:

He that has that ruling enthusiasm which accompanies abilities cannot look superficially. Every glance is a glance for study . . . Every look at nature is a refinement upon art. Each tree and blade of grass or flower, is not to him the individual tree, grass or flower, but what it is in relation to the whole, its tone, its contrast and its use, and how far practicable admiring Nature by the power and practicability of his Art, and judging of his Art by the perceptions drawn from Nature.

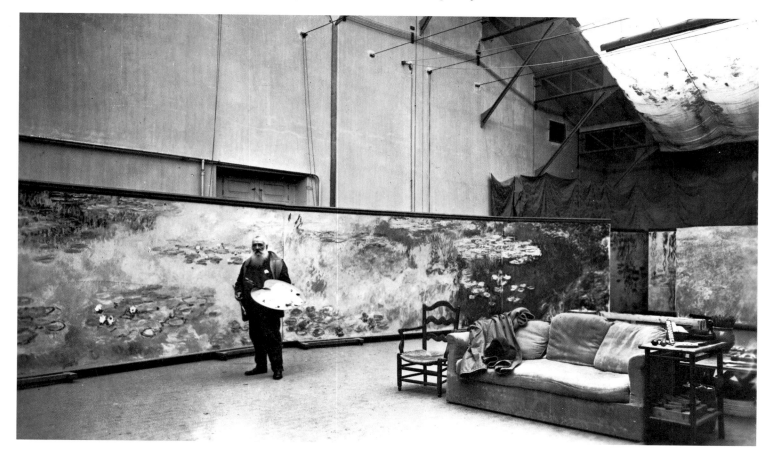

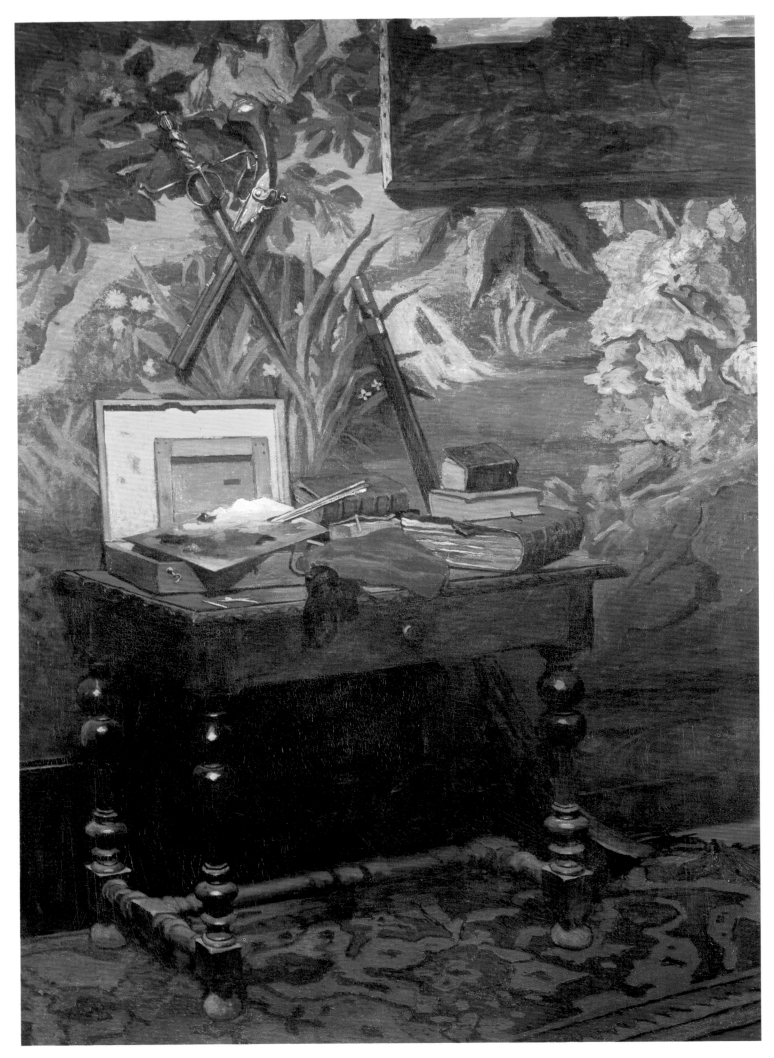

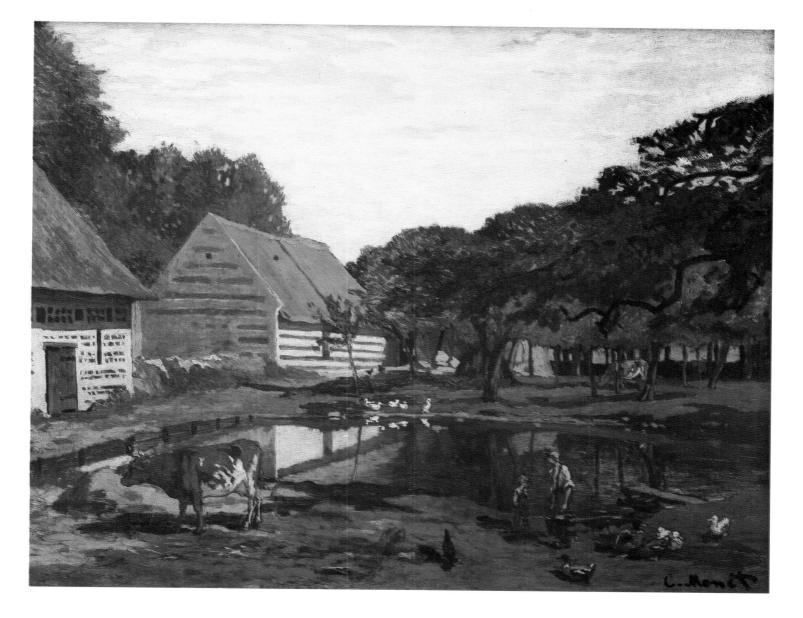

ABOVE
Normandy Farmyard, 1863
Oil on canvas, 25½×32 inches (65×81.3 cm)
Musée d'Orsay, Paris

LEFT
A Corner of the Studio, 1861
Oil on canvas, 72×49½ inches (182×127 cm)
Musée d'Orsay, Paris

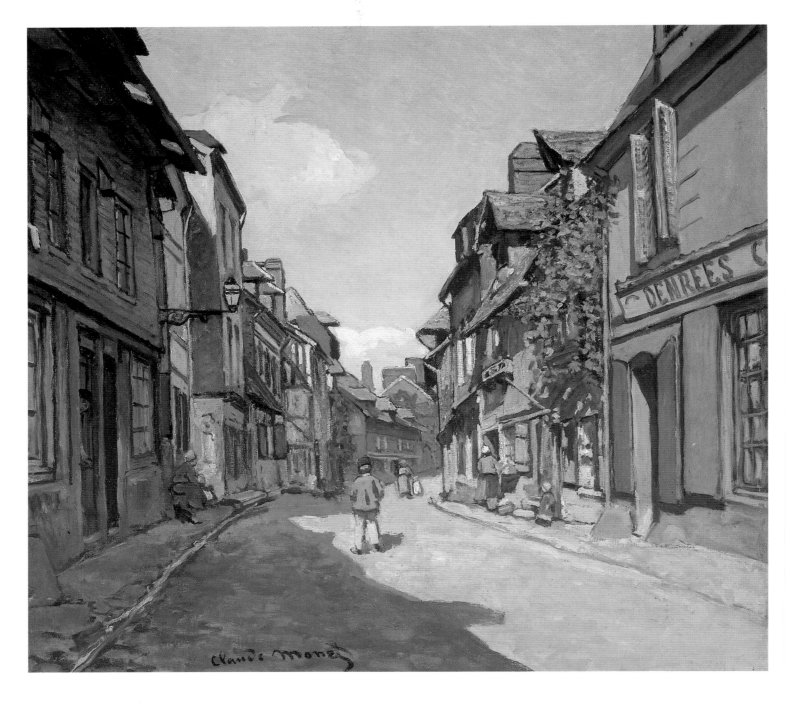

Rue de la Bavolle, Honfleur, 1864
Oil on canvas, 22×24 inches (55.9×61 cm)
Museum of Fine Arts, Boston, Bequest of John T. Spaulding

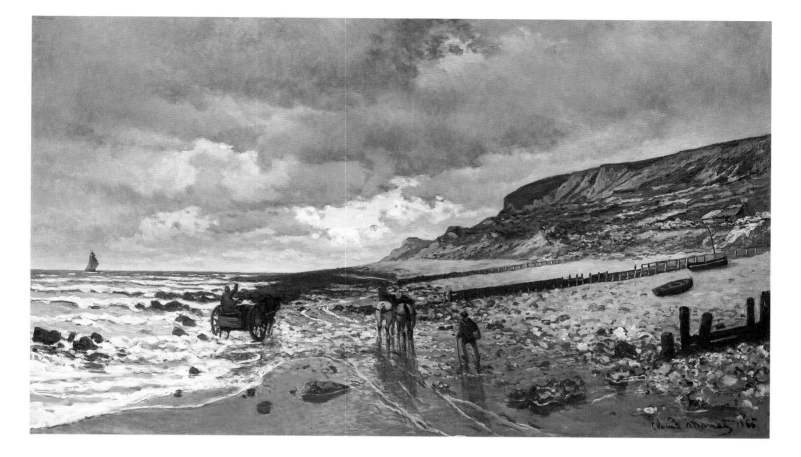

La Pointe de la Hève at Low Tide, 1864-65
Oil on canvas, 35½×59½ inches (90.2×150.5 cm)
Kimbell Art Museum, Fort Worth, Texas

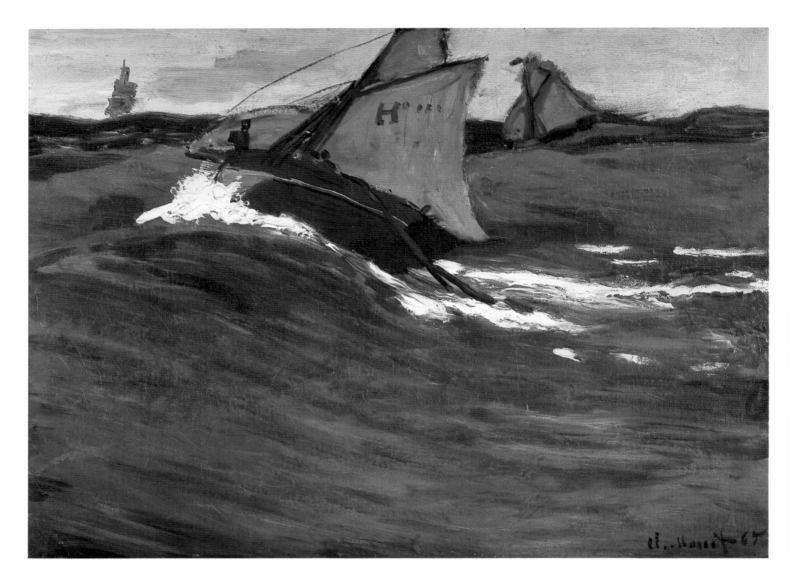

The Blue Wave, 1865
Oil on canvas, 19¾×25½ inches (48.6×64.8 cm)
Metropolitan Museum of Art, New York, Bequest of
Mrs H. O. Havemeyer, 1929, The Havemeyer Collection

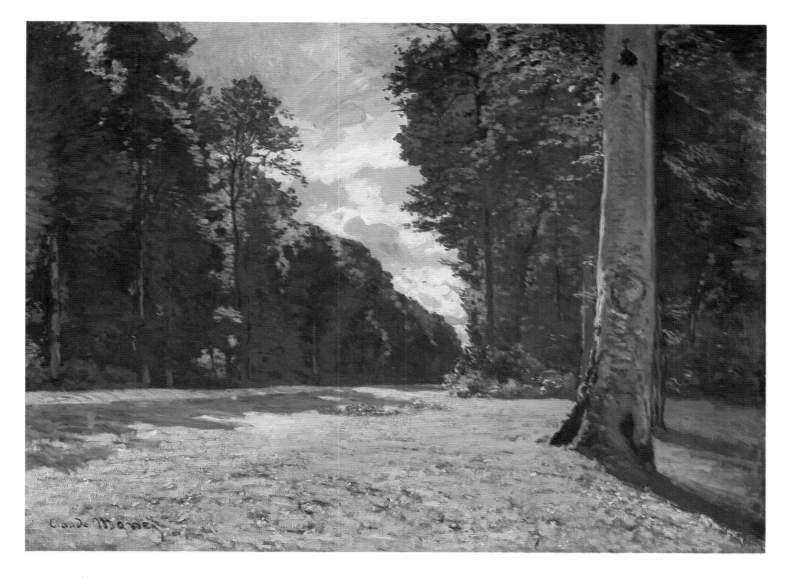

The Road from Chailly to Fontainebleau, 1865
Oil on canvas, 38¼×51¼ inches (97×130 cm)
The Ordrupgaard Collection, Copenhagen

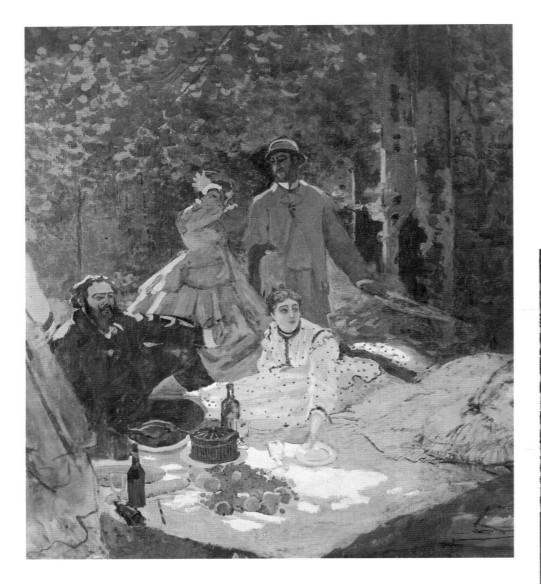

Le Déjeuner sur l'Herbe (fragment), 1865-66
Oil on canvas, 97½×59 inches (248×150 cm)
Eknayen Collection, Paris

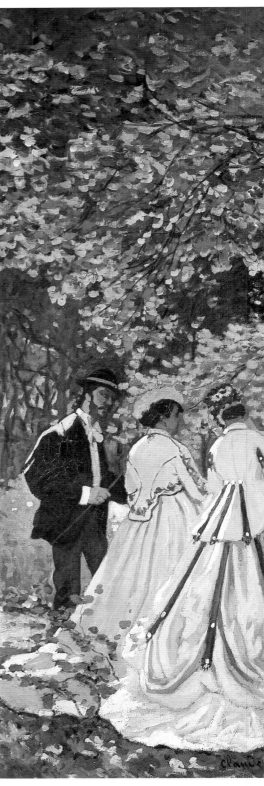

Le Déjeuner sur l'Herbe (final study), 1865 (dated 1866)
Oil on canvas, 51¼×71¼ inches (130×181 cm)
Pushkin Museum, Moscow

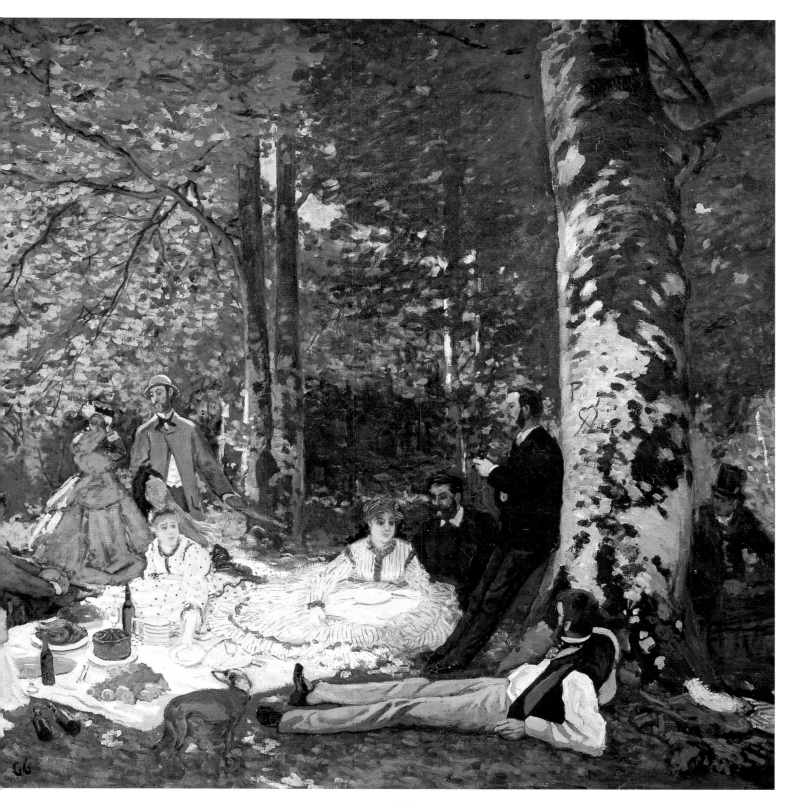

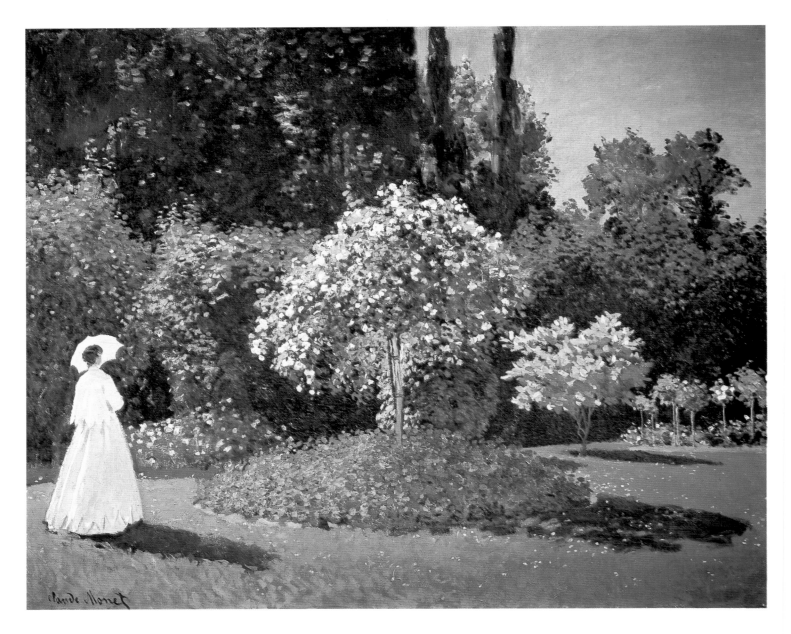

ABOVE
Jeanne-Marguerite Lecadre in the Garden, *c.*1866
Oil on canvas, 31½×28 inches (80×109.9 cm)
Hermitage Museum, St Petersburg

RIGHT
Camille: The Green Dress, 1866
Oil on canvas, 91×59½ inches (231×151 cm)
Kunsthalle, Bremen

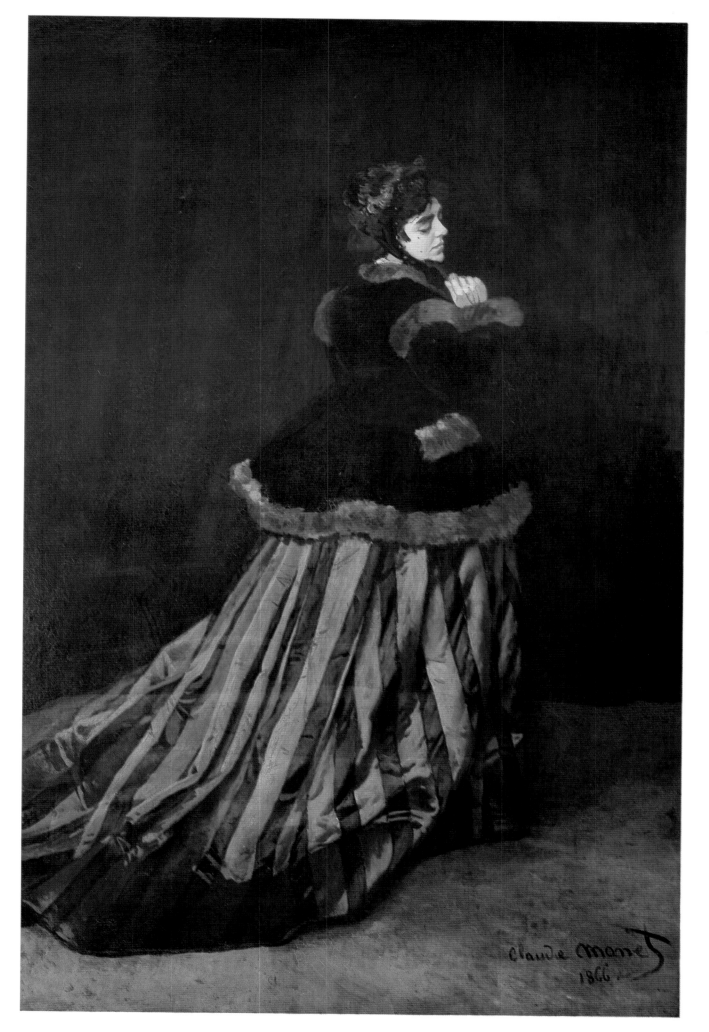

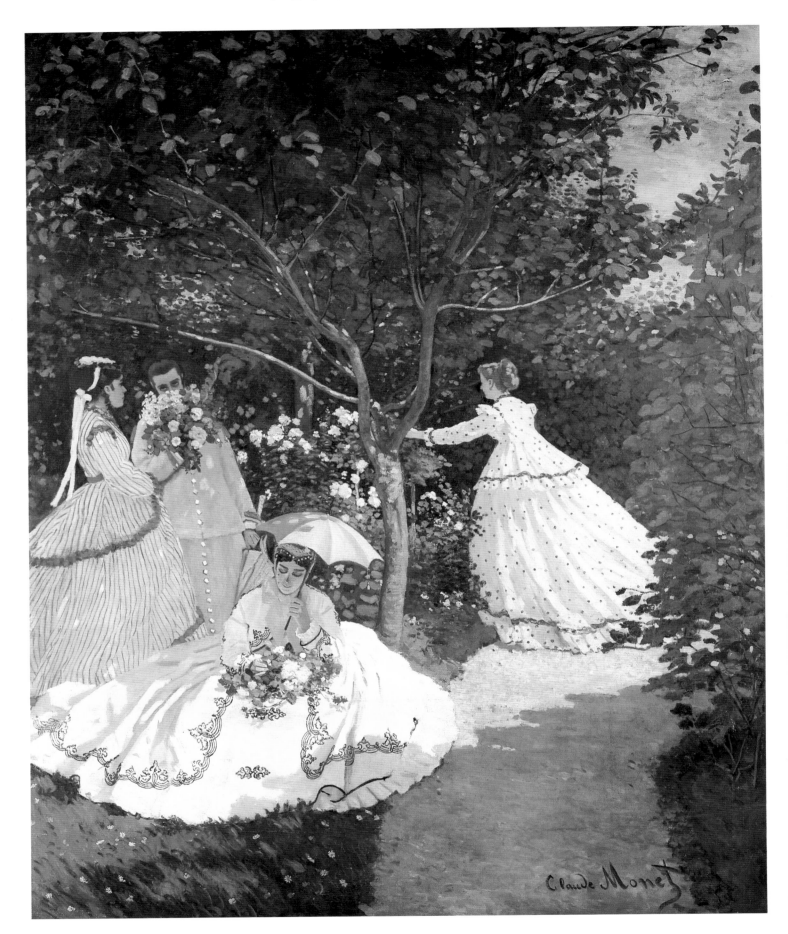

ABOVE
The Women in the Garden, 1866-67
Oil on canvas, 100½×80¾inches (255×205 cm)
Musée d'Orsay. Paris

RIGHT
The Garden of the Princess, Louvre, 1867
Oil on canvas, 35¾×24½ inches (91×62 cm)
Allen Memorial Art Museum. Oberlin. Ohio (R T Miller Fund)

28

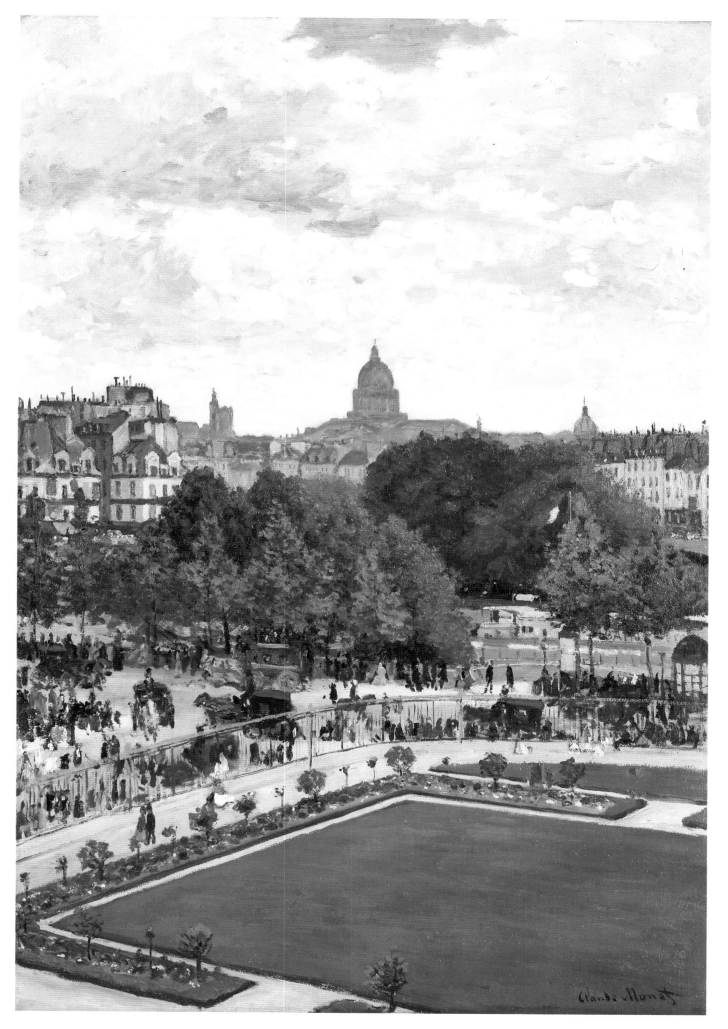

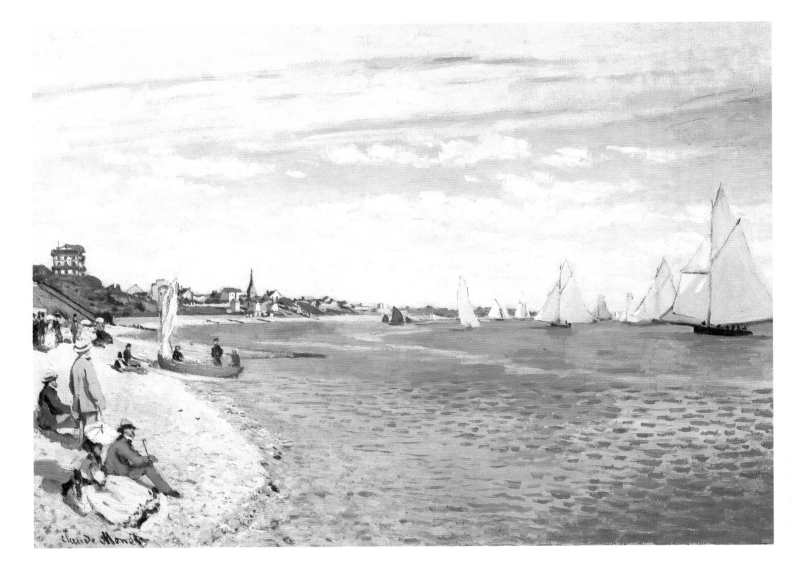

ABOVE
The Regatta at Sainte-Adresse, 1867
Oil on canvas, 29³/₄×40 inches (75.3×101 cm)
Metropolitan Museum of Art, New York,
Bequest of William Church Osborn, 1951

RIGHT
The Cradle: Camille and the Artist's Son Jean, 1867
Oil on canvas, 46×35 inches (116.8×88.9 cm)
National Gallery of Art, Washington,
Collection of Mr and Mrs Paul Mellon

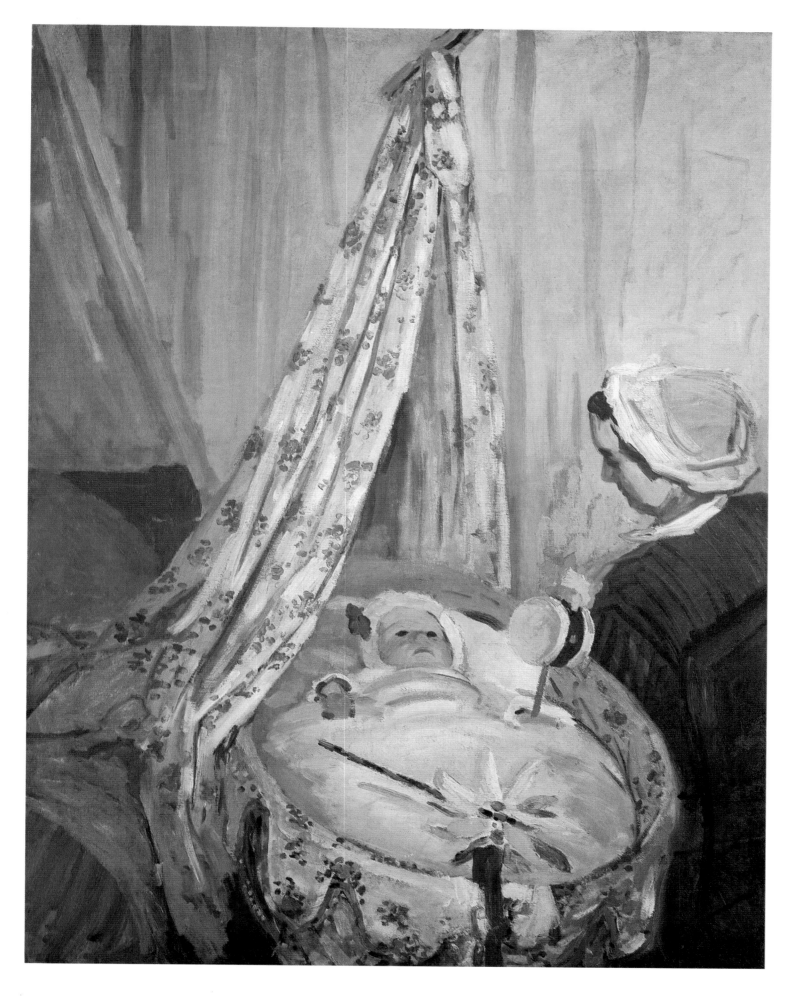

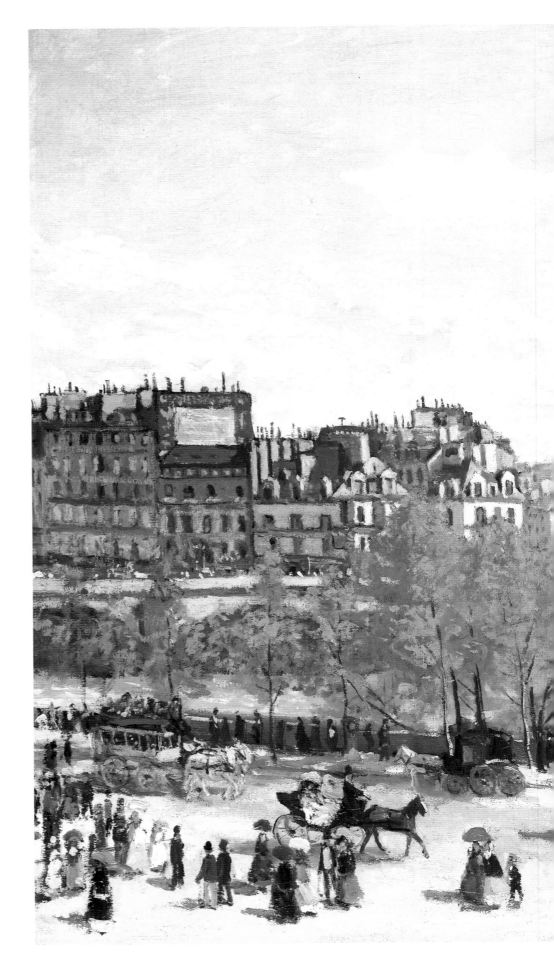

The Quai du Louvre, 1867
Oil on canvas, 36½×25½ inches (93×65 cm)
Haags Gemeentemuseum, The Hague

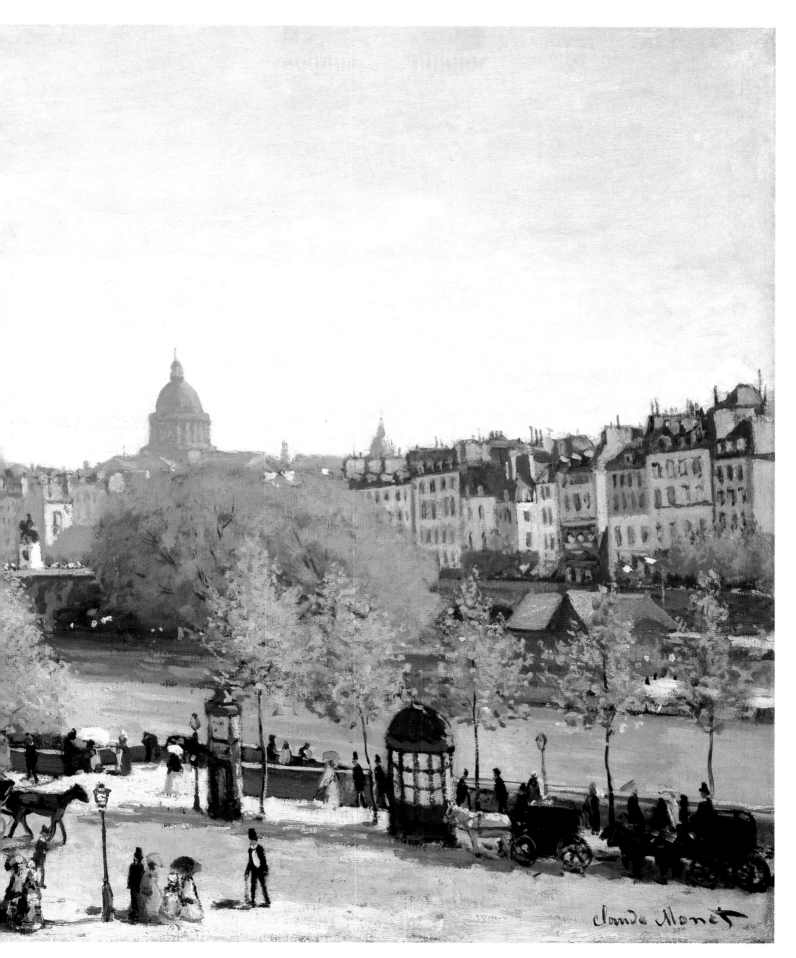

Claude Monet

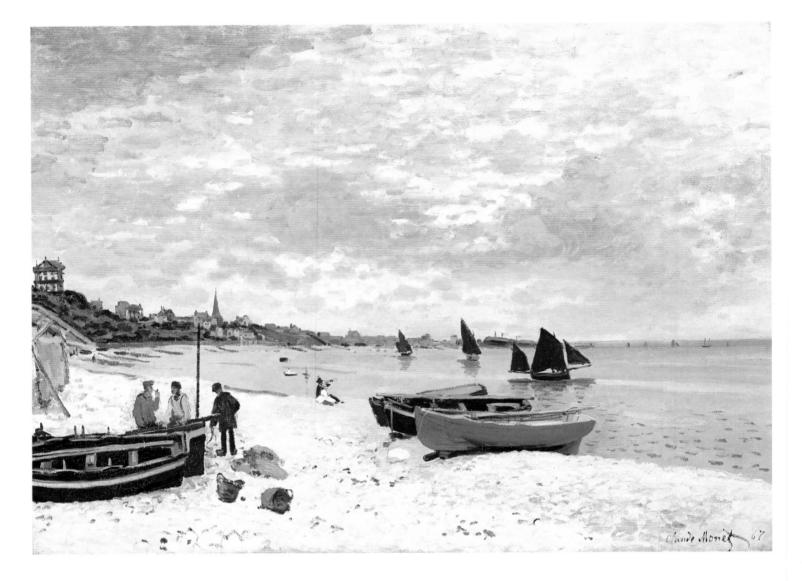

ABOVE
The Beach at Sainte-Adresse, 1867
Oil on canvas, 29¾×40¾ inches (75.8×102.5 cm)
Art Institute of Chicago,
Mr and Mrs Lewis Larned Coburn Memorial Collection

RIGHT
The Luncheon, 1868
Oil on canvas, 90½×59½ inches (230×150 cm)
Städelsches Kunstinstitut, Frankfurt

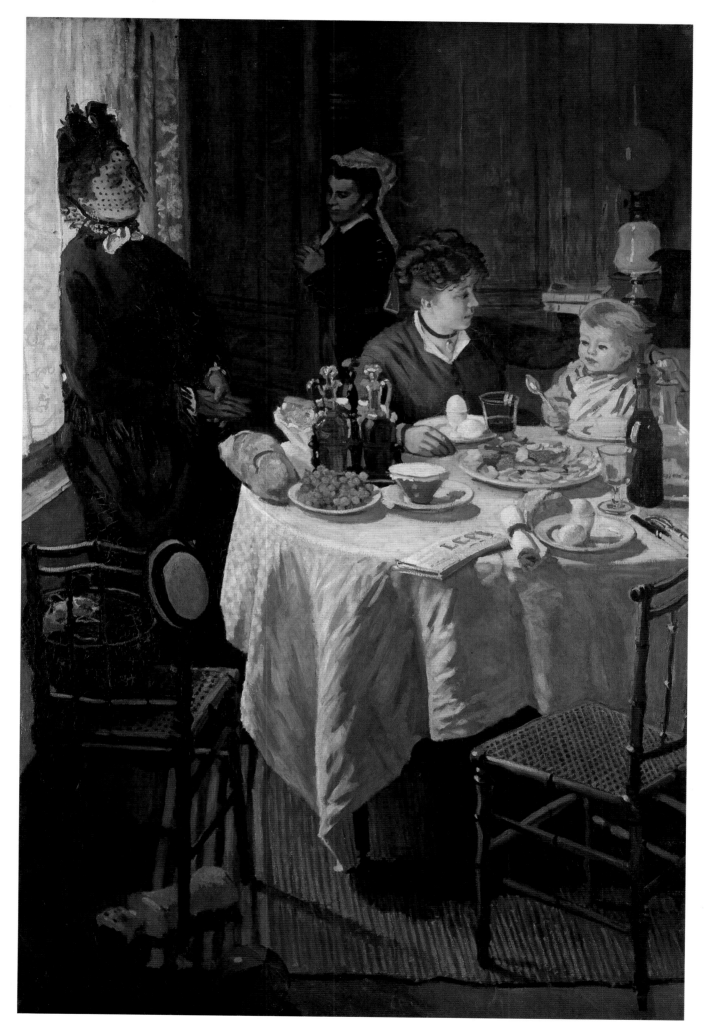

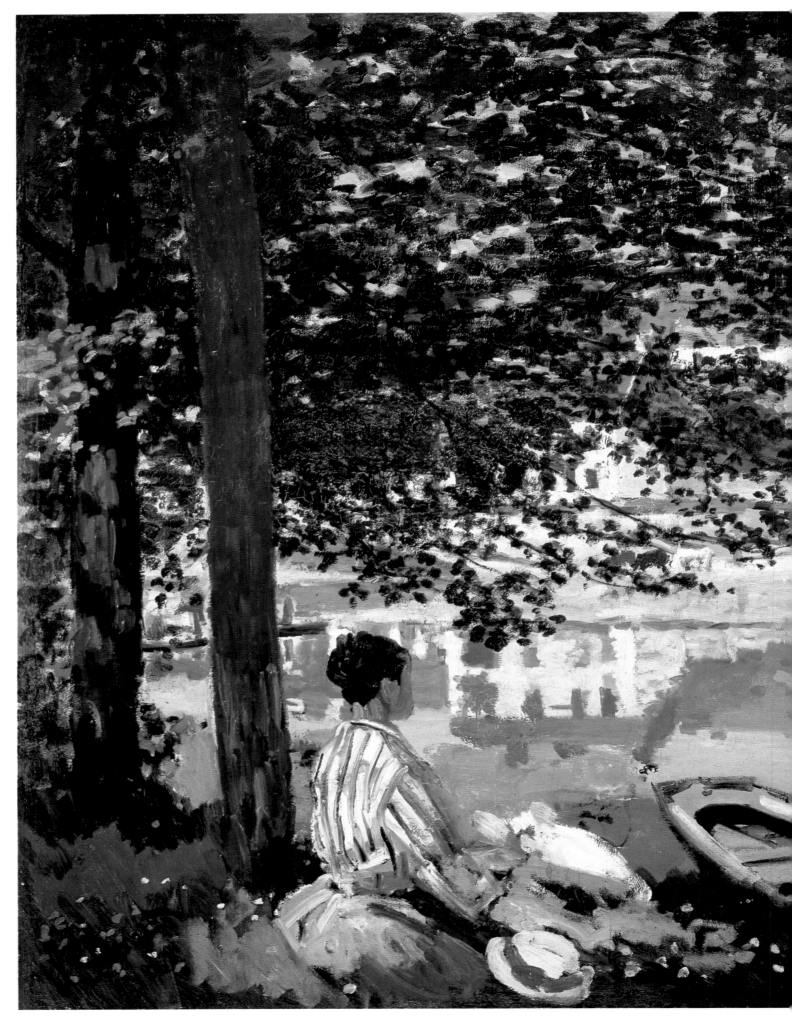

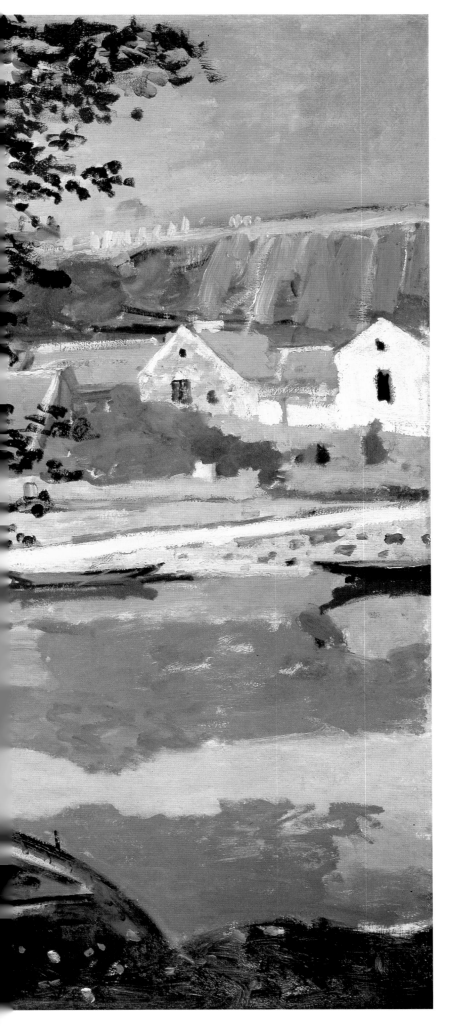

On the Seine at Bennecourt, 1868
Oil on canvas, 32×39¾ inches (81.5×100.7 cm)
Art Institute of Chicago, Potter Palmer Collection

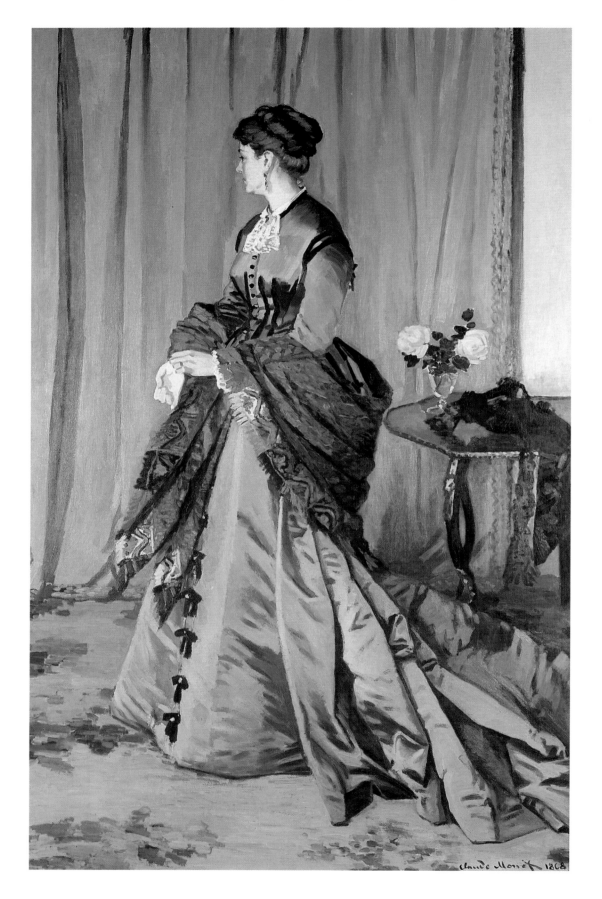

Madame Gaudibert, 1868
Oil on canvas, 85×54½ inches (215.9×138.4 cm)
Musée d'Orsay, Paris

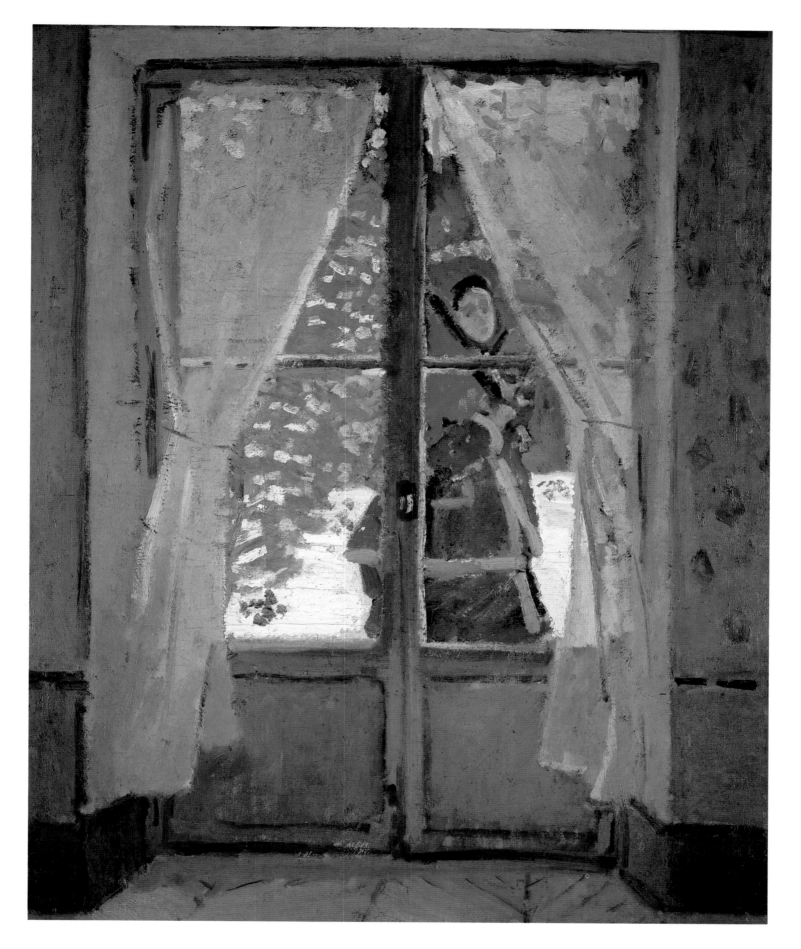

The Red Cape, Madame Monet, *c.*1870
Oil on canvas, 39½×31½ inches (100×80 cm)
Cleveland Museum of Art, Bequest of Leonard C Hanna Jr, 58.39

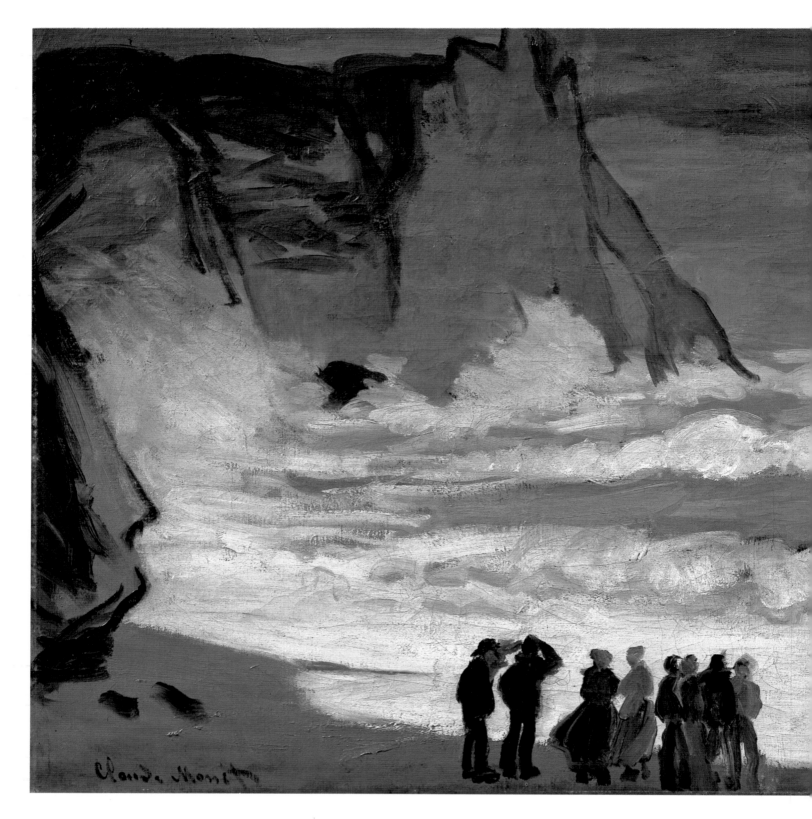

Stormy Sea at Etretat, *c.*1868-69
Oil on canvas, 26×51½ inches (66×131 cm)
Musée d'Orsay, Paris

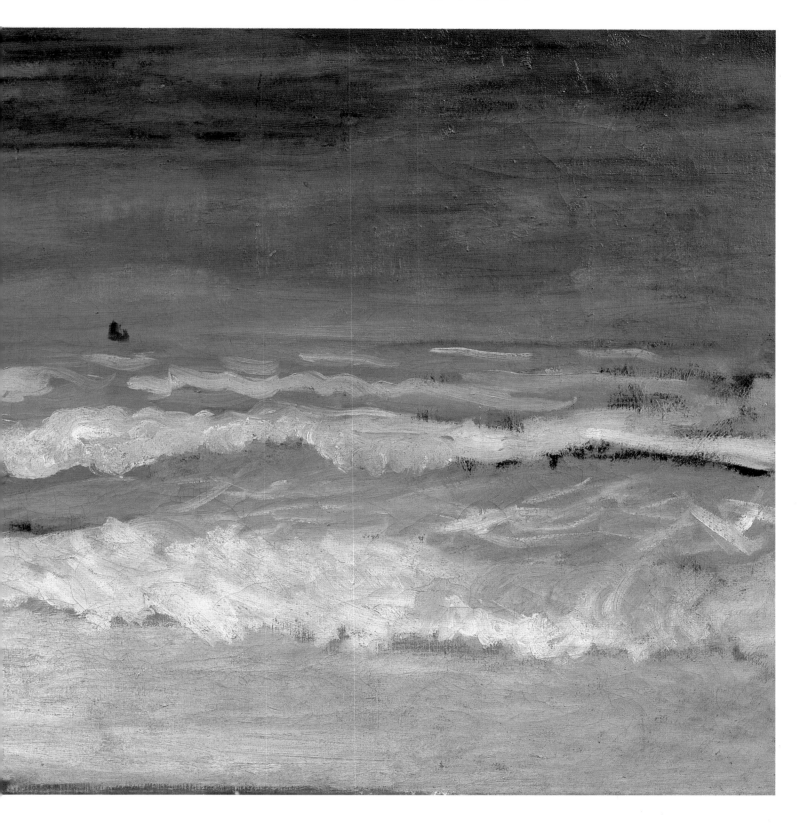

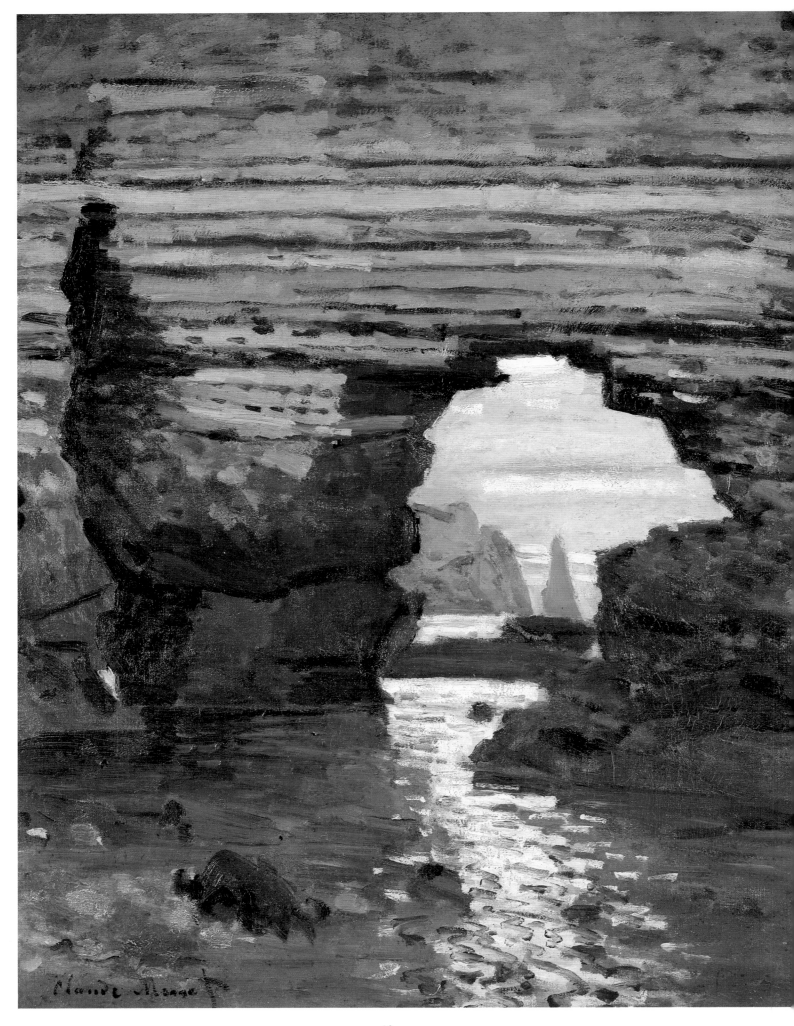

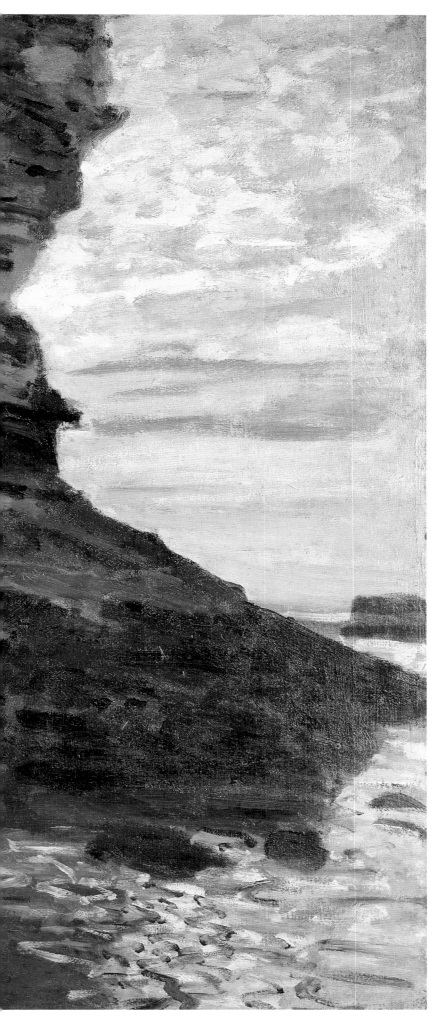

Cliff at Etretat, *c.*1868
Oil on canvas, 32×39¼ inches (81×100 cm)
Fogg Art Museum, Cambridge, Massachusetts,
Gift of Mr and Mrs Joseph Pulitzer Jr

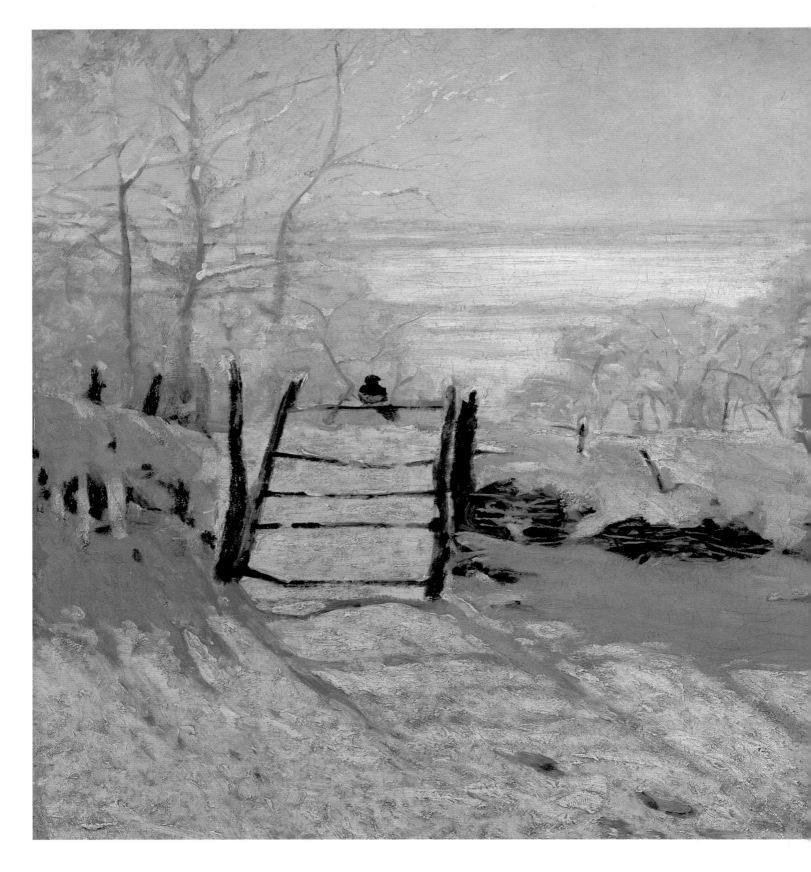

The Magpie, Winter, 1868-69
Oil on canvas, 35×51¼ inches (89×130 cm)
Musée d'Orsay, Paris

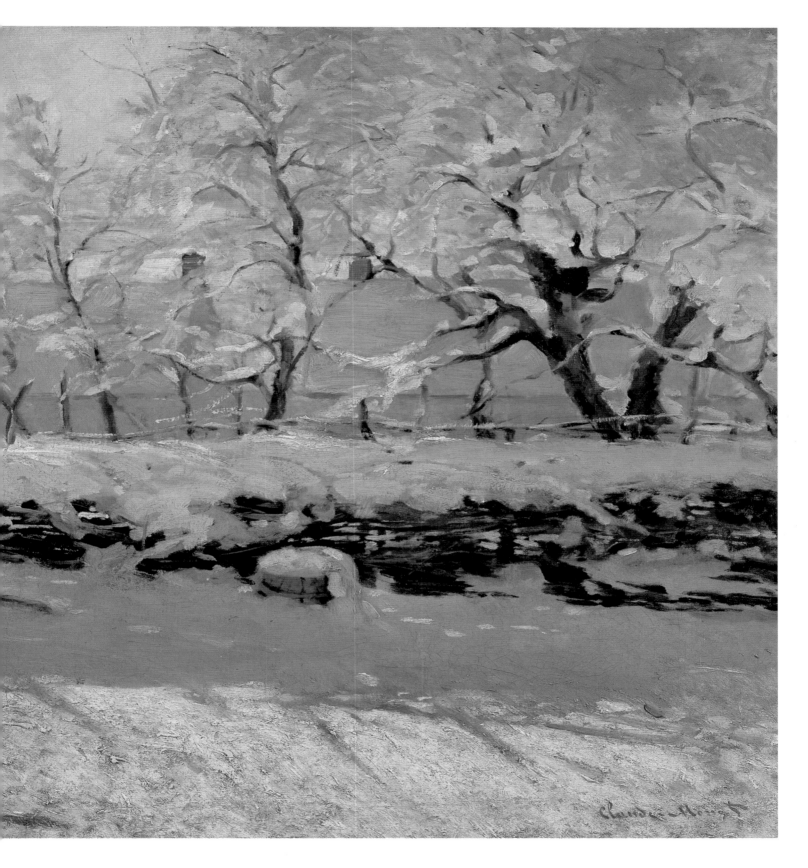

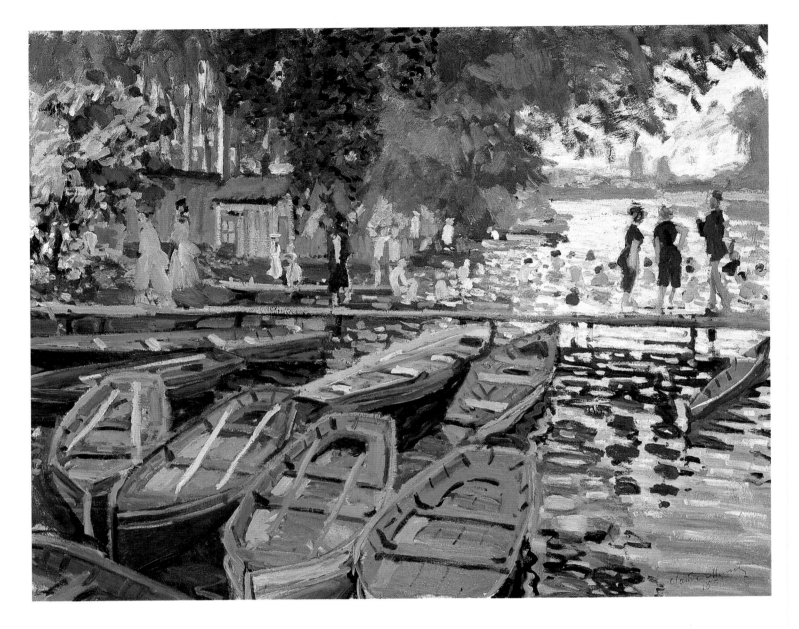

Bathers at La Grenouillère, 1869
Oil on canvas, 30½×36½ inches (77×92 cm)
The National Gallery, London

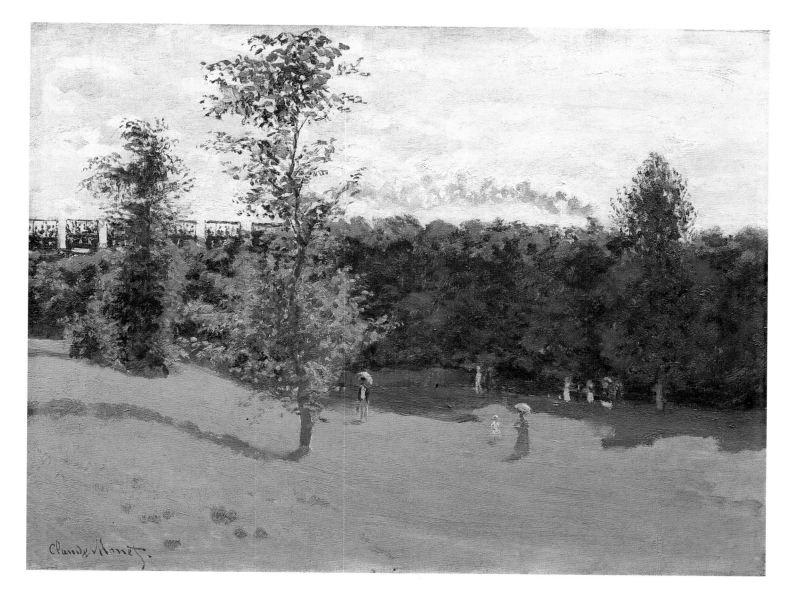

Train in the Country, 1870
Oil on canvas, 19¾×25½ inches (50×65 cm)
Musée d'Orsay, Paris

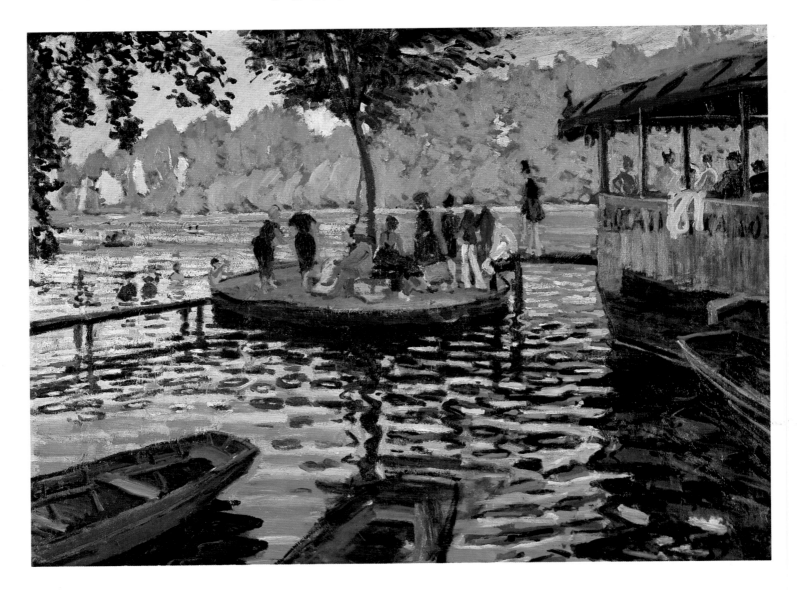

ABOVE
La Grenouillère, 1869
Oil on canvas, 30¼×39¾ inches (77×101 cm)
Metropolitan Museum of Art, New York,
Bequest of Mrs H O Havemeyer, 1929, The Havemeyer
Collection

RIGHT
The Hôtel des Roches Noires at Trouville, 1870
Oil on canvas, 31½×21¾ inches (80×55 cm)
Musée d'Orsay, Paris

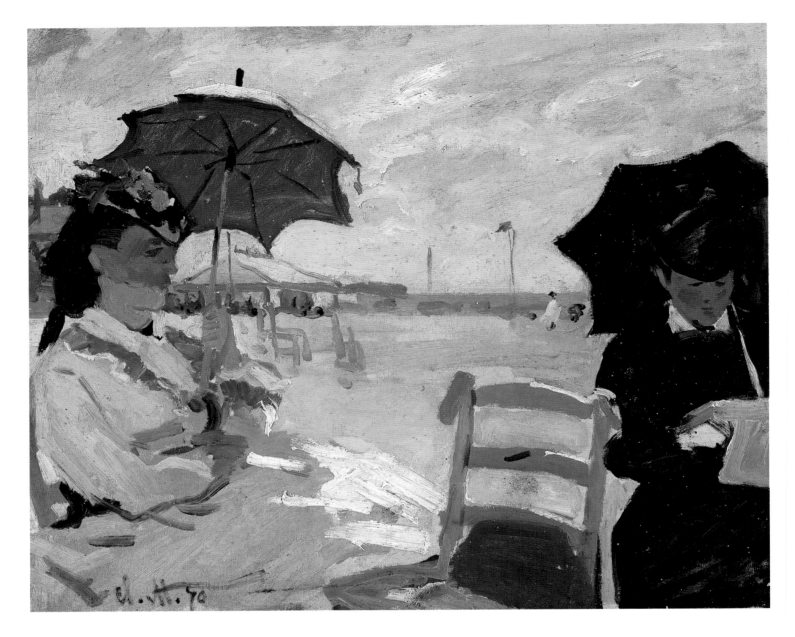

The Beach at Trouville, *c.*1870
Oil on canvas, 14³/₄×18 inches (37.5×45.7 cm)
The National Gallery, London

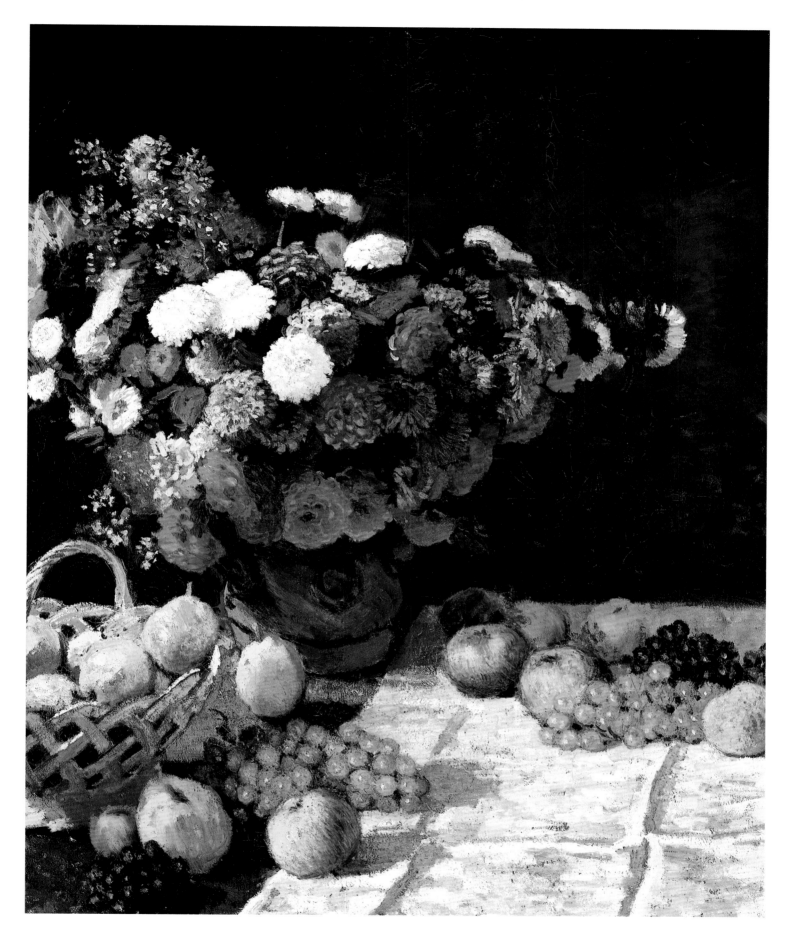

Still Life with Flowers and Fruit, *c.*1869
Oil on canvas, 41½×31½ inches (106×81 cm)
J Paul Getty Museum, Malibu, Florida

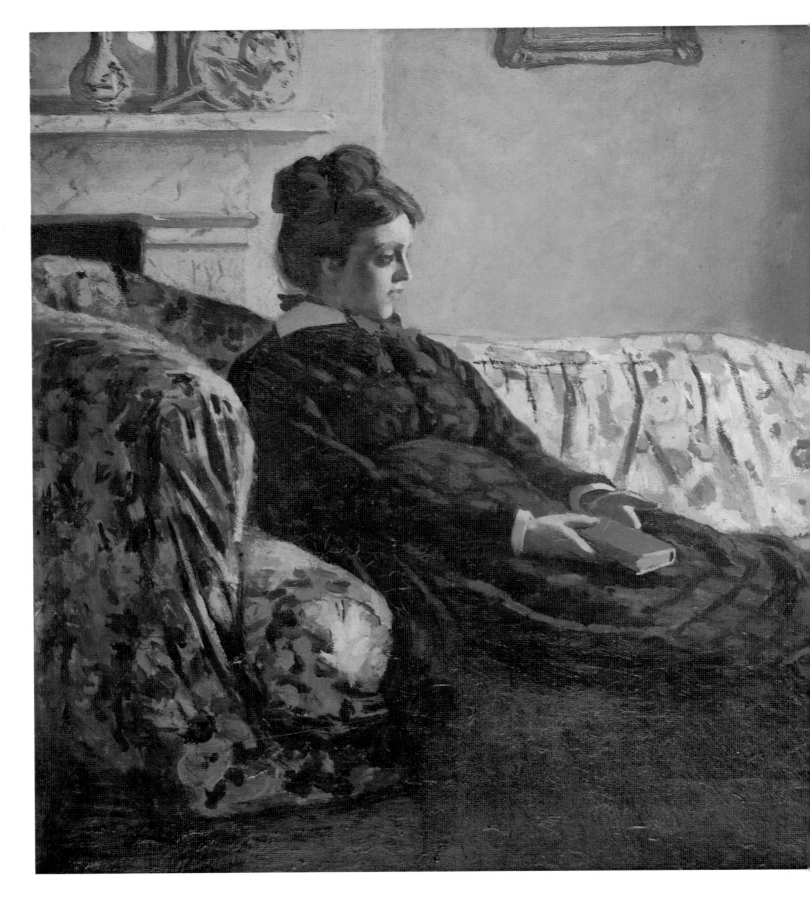

Meditation, Madame Monet, *c.*1870-71
Oil on canvas, 19×29½inches (48×75 cm)
Musée d'Orsay, Paris

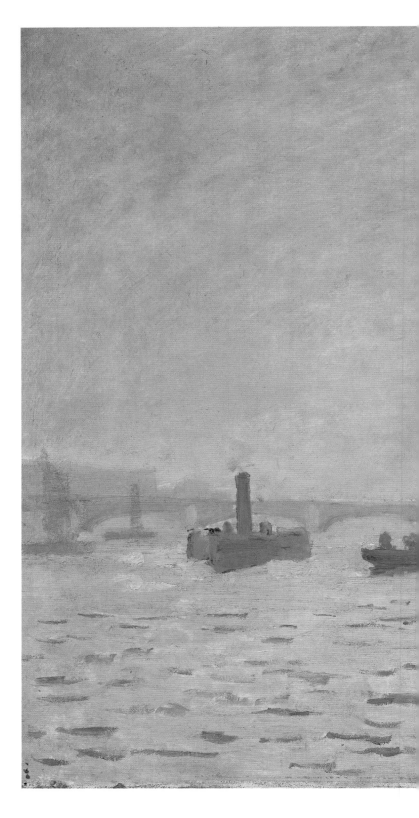

The Thames and Westminster, 1870-71
Oil on canvas, 18½×17 inches (47×43 cm)
The National Gallery, London

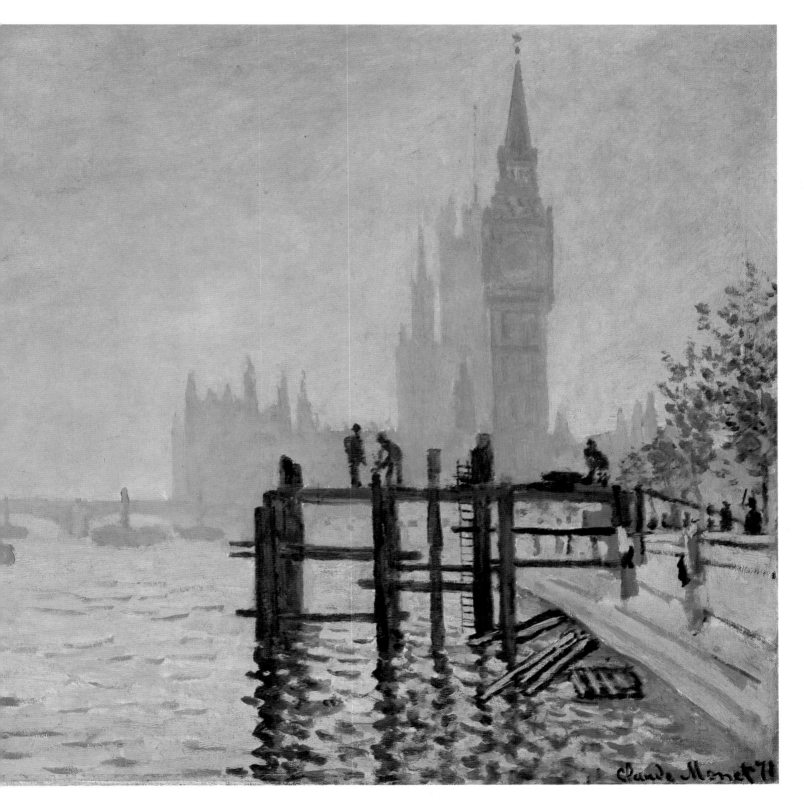

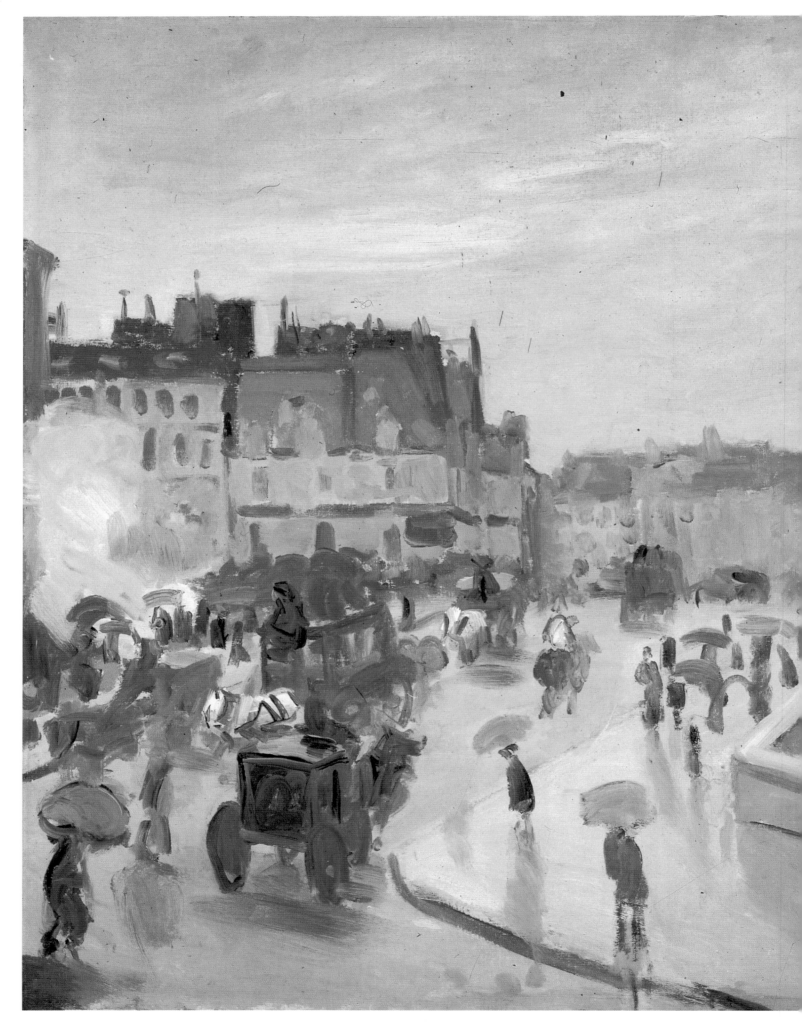

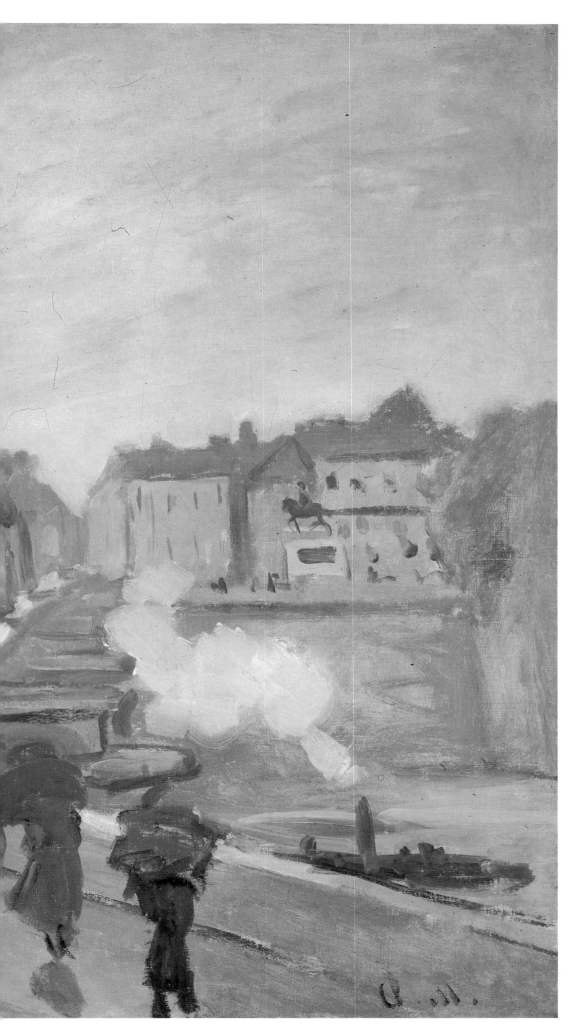

The Pont Neuf, Paris,
1872
*Oil on canvas, 21×28½ inches
(53.2×72.4 cm)*
Dallas Museum of Art. The
Wendy and Emery Reeves
Collection

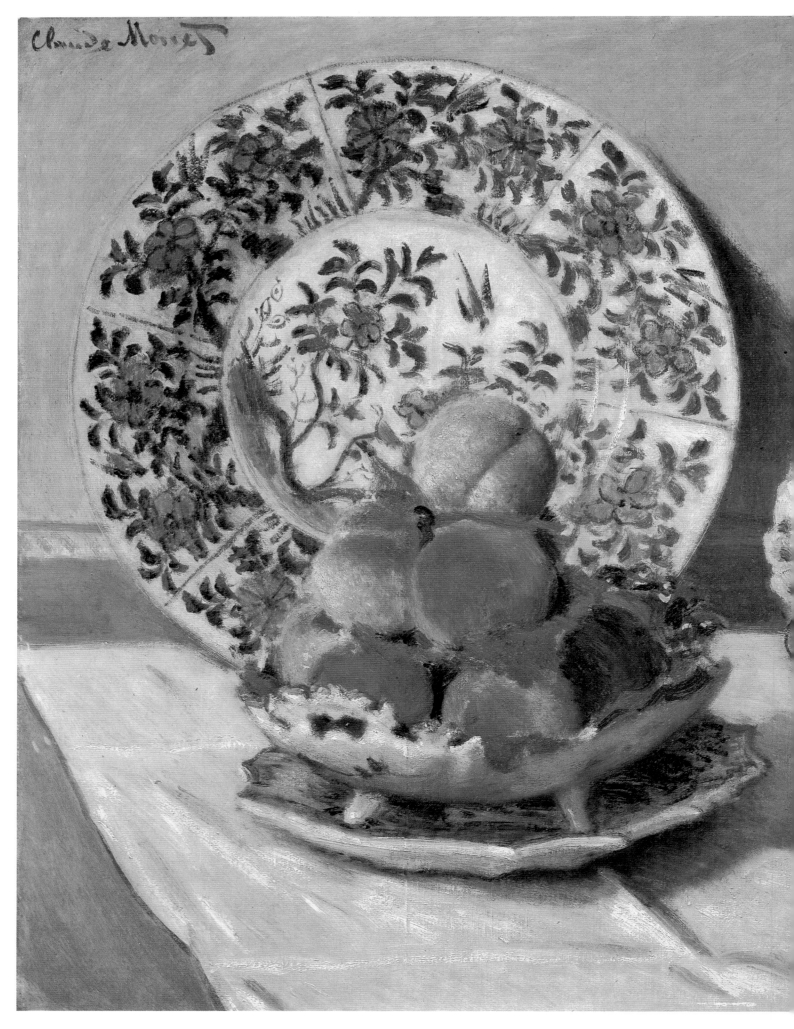

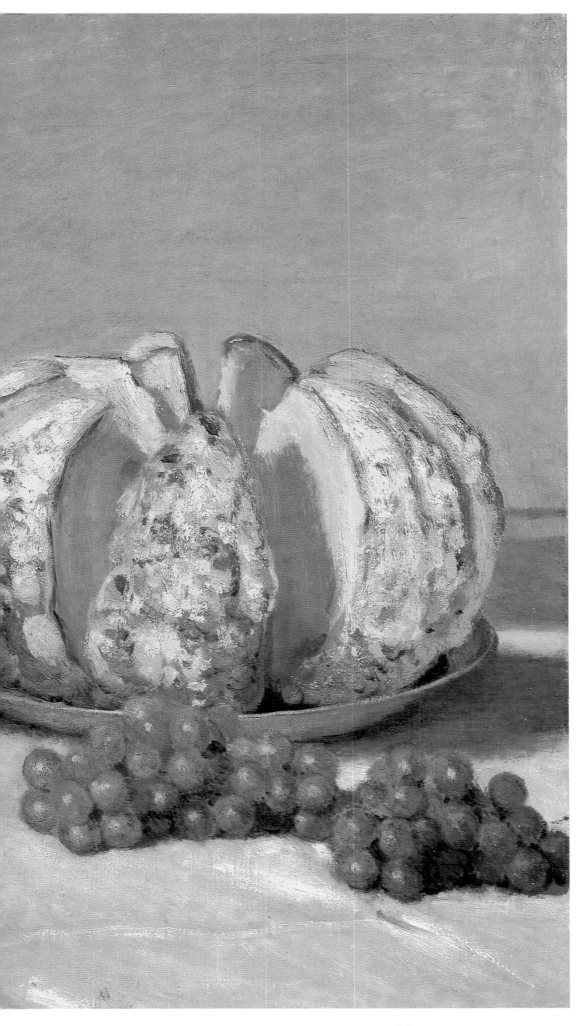

Still Life with Melon,
c.1872
Oil on canvas, 21×28¾
inches (53×73 cm)
Calouste Gulbenkian Museum,
Lisbon

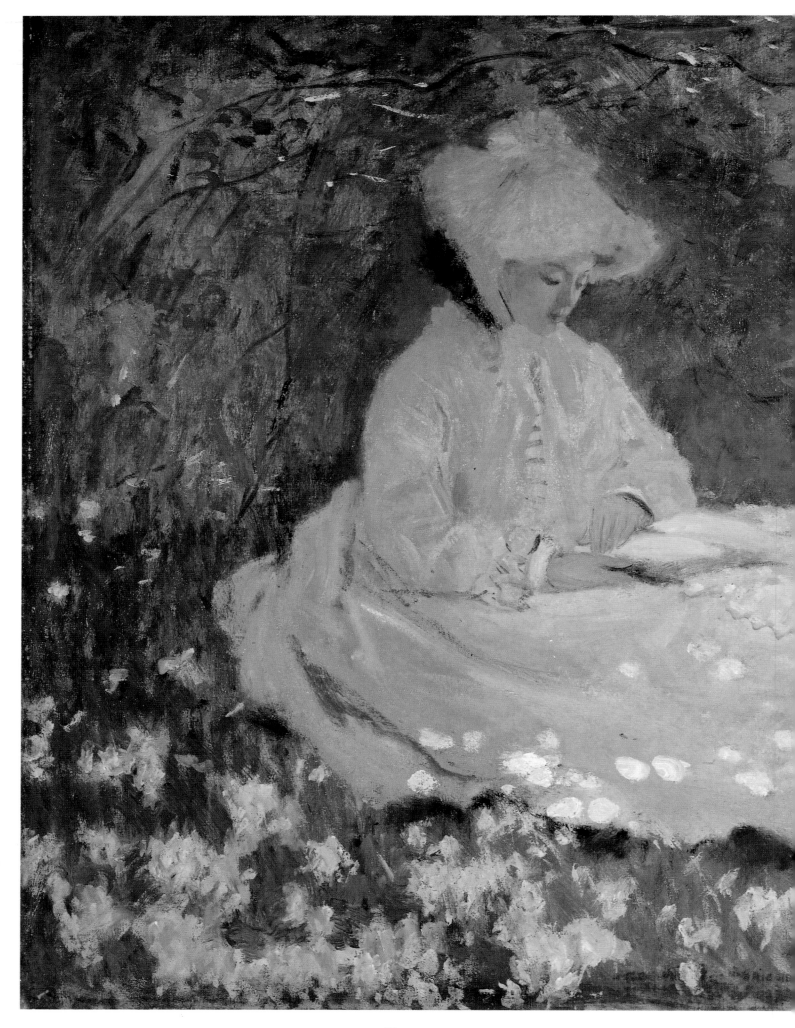

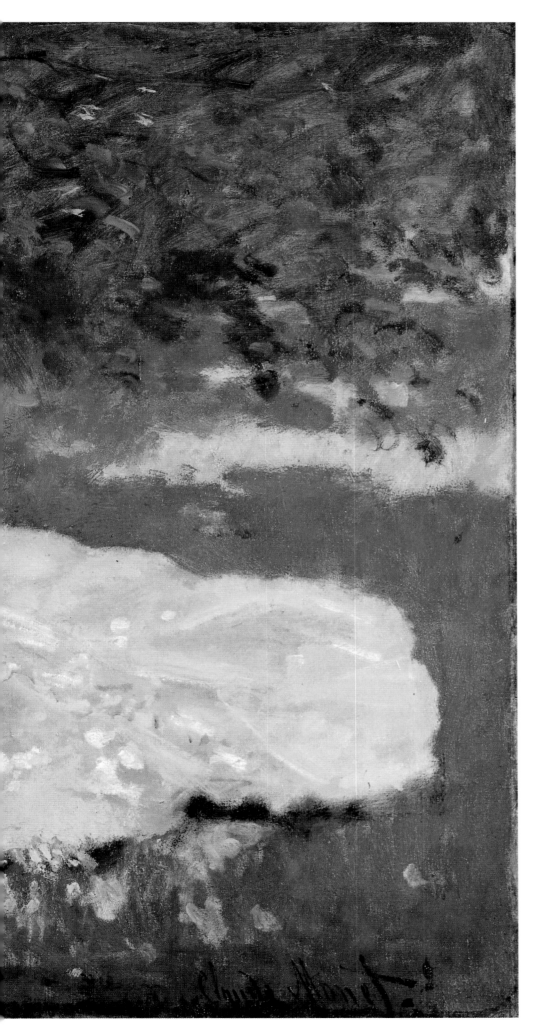

Springtime, *c.*1872-74
Oil on canvas,
19¾×25½ inches (50×65 cm)
Walters Art Gallery, Baltimore

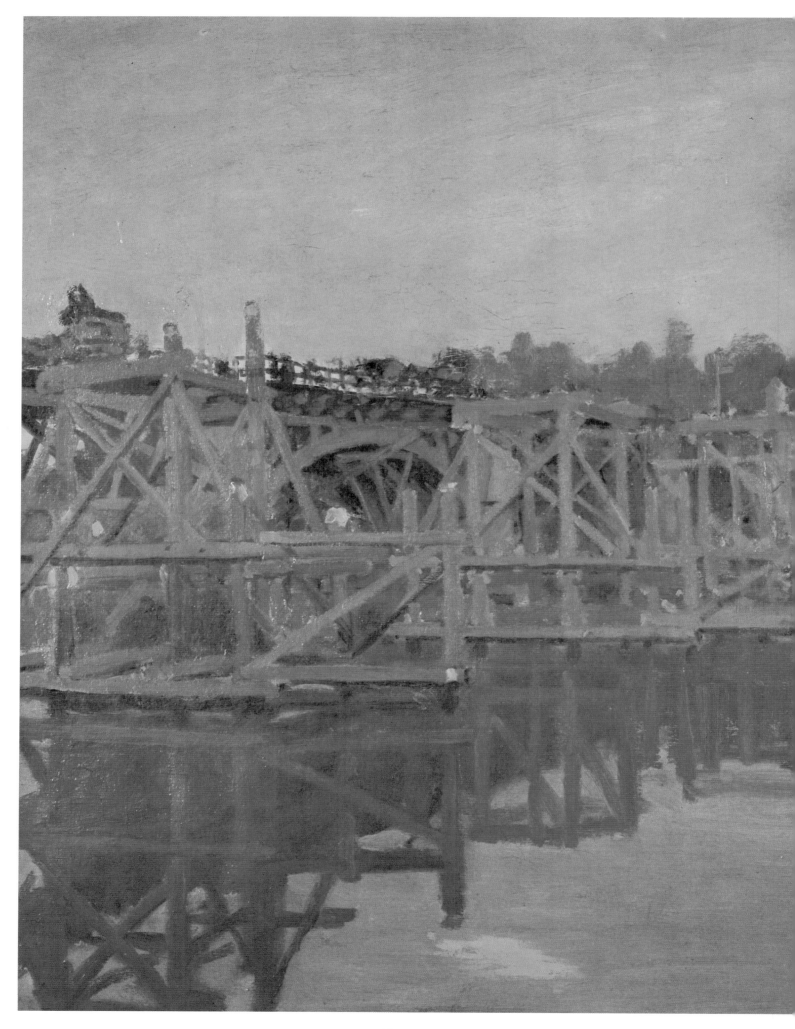

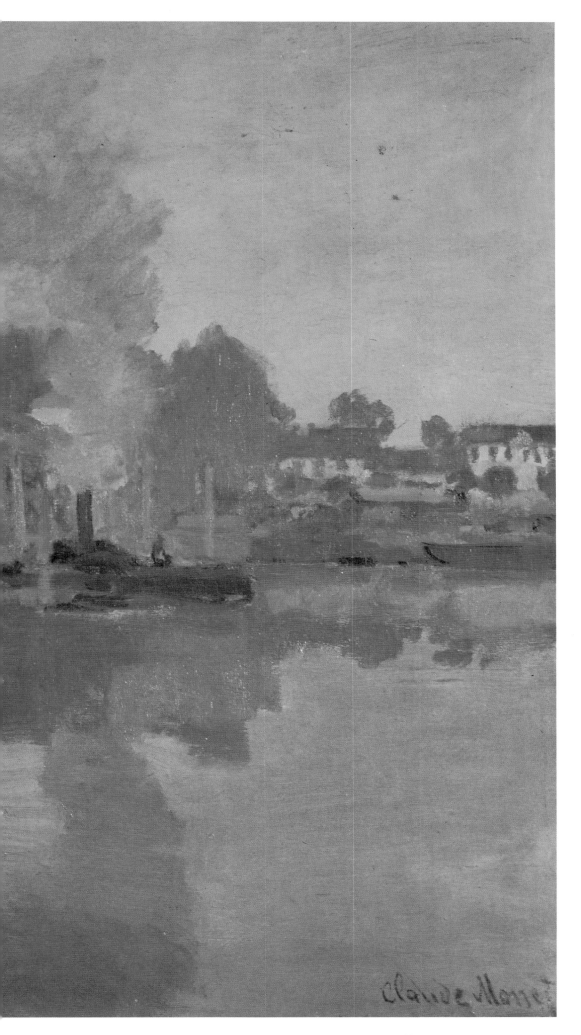

**The Bridge at Argenteuil
under Repair,** 1872
*Oil on canvas, 23½×31¾
inches (60×80.5 cm)*
Private Collection.
Fitzwilliam Museum, Cambridge

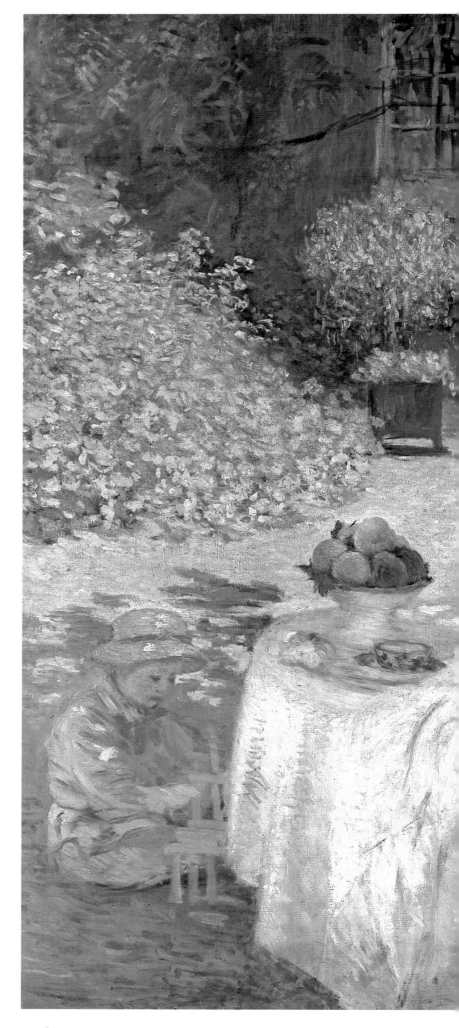

The Luncheon, *c.*1873-74
Oil on canvas, 63×79¼ inches (160×201 cm)
Musée d'Orsay, Paris

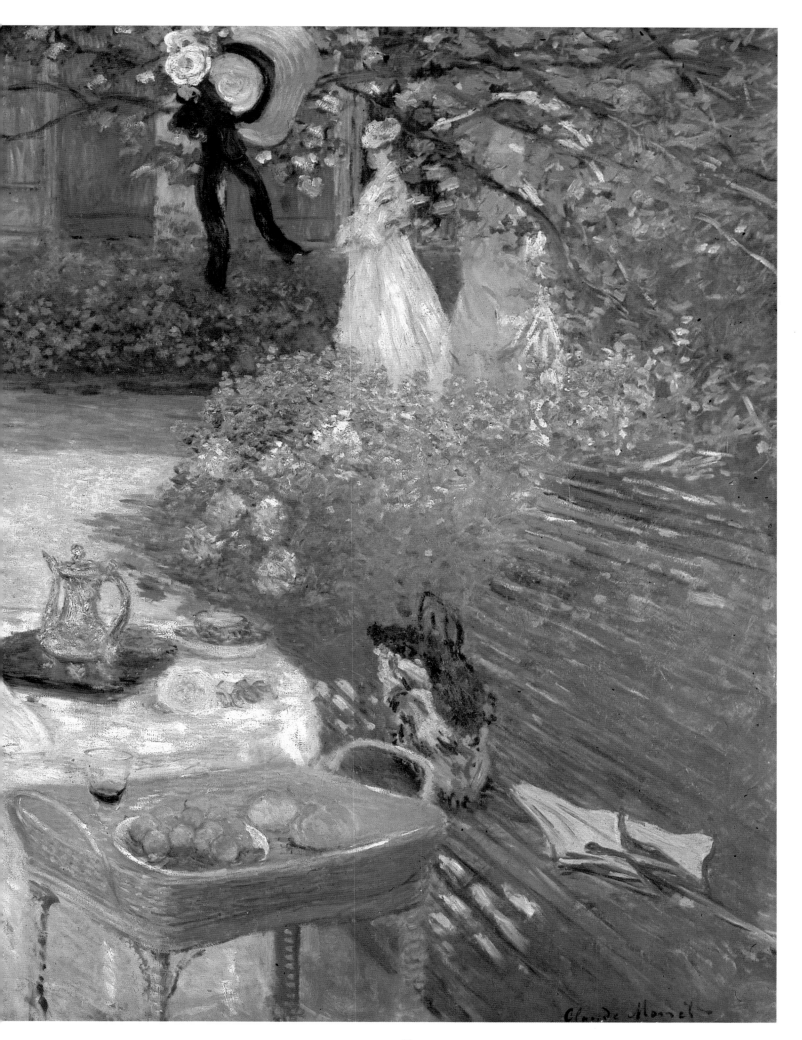

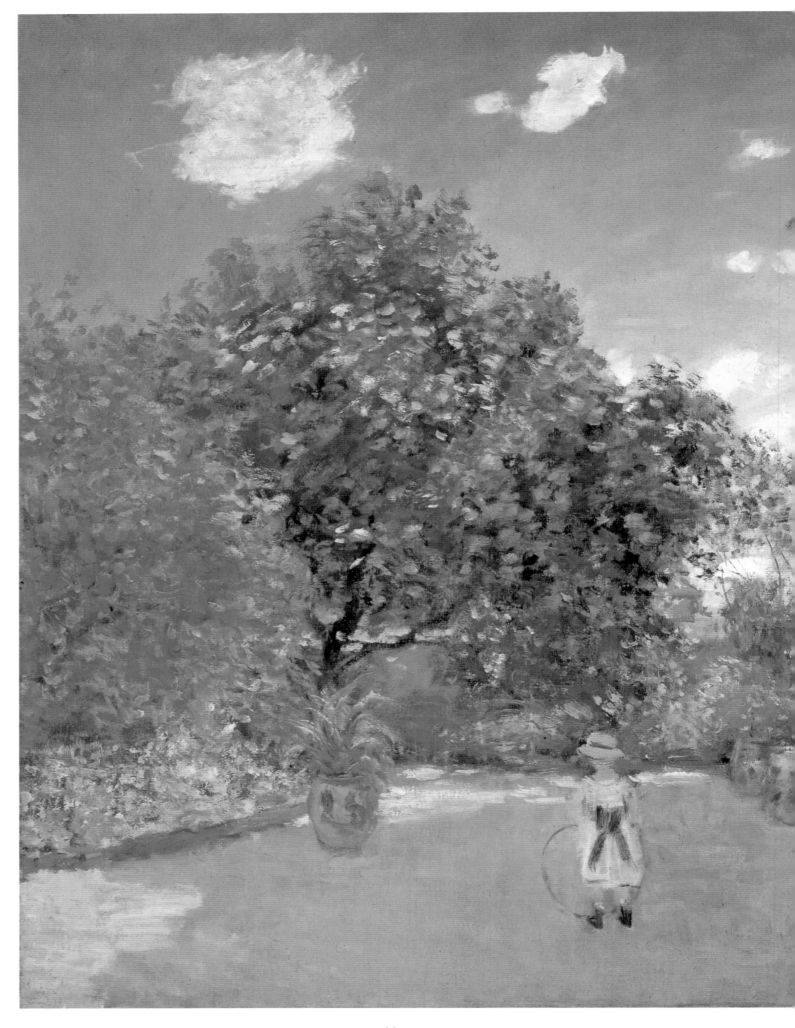

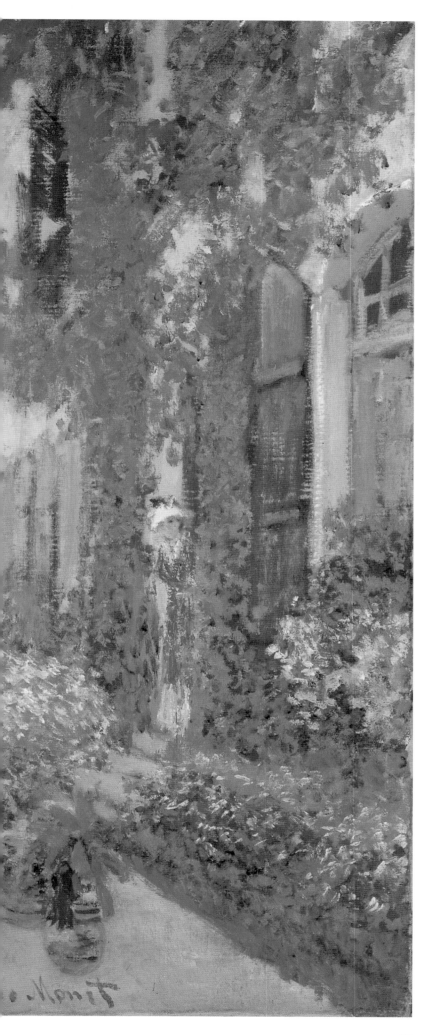

Monet's House at Argenteuil, *c.1873*
Oil on canvas, 23¾×34½ inches (60.2×73.3 cm)
Art Institute of Chicago.
Mr and Mrs Martin A Ryerson Collection

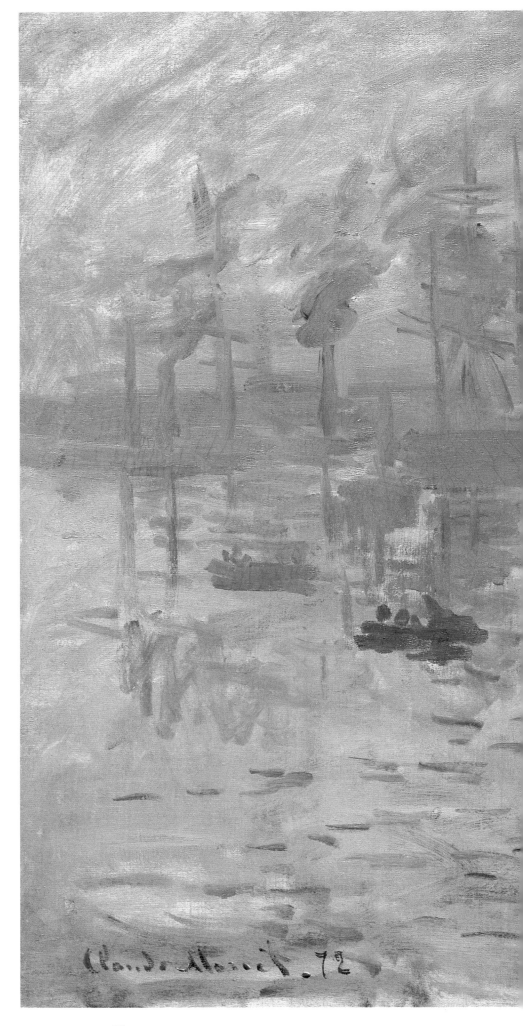

Impression, Sunrise, 1872
Oil on canvas, 19×24¾ inches
(48×63 cm)
Musée Marmottan, Paris

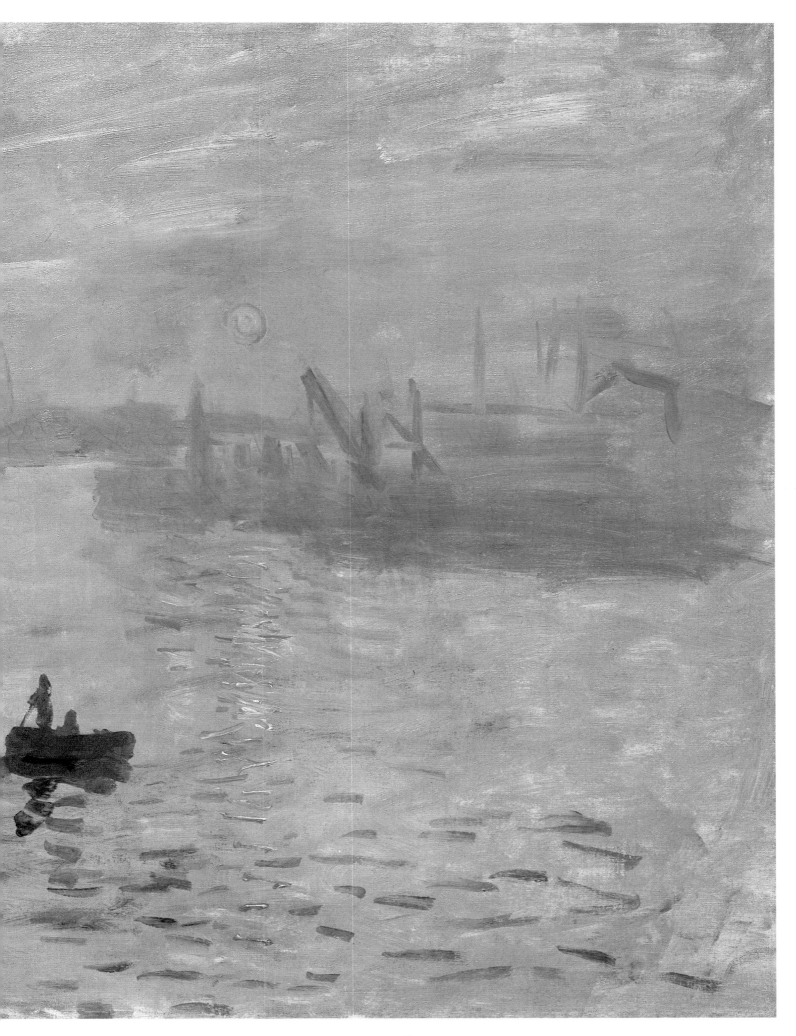

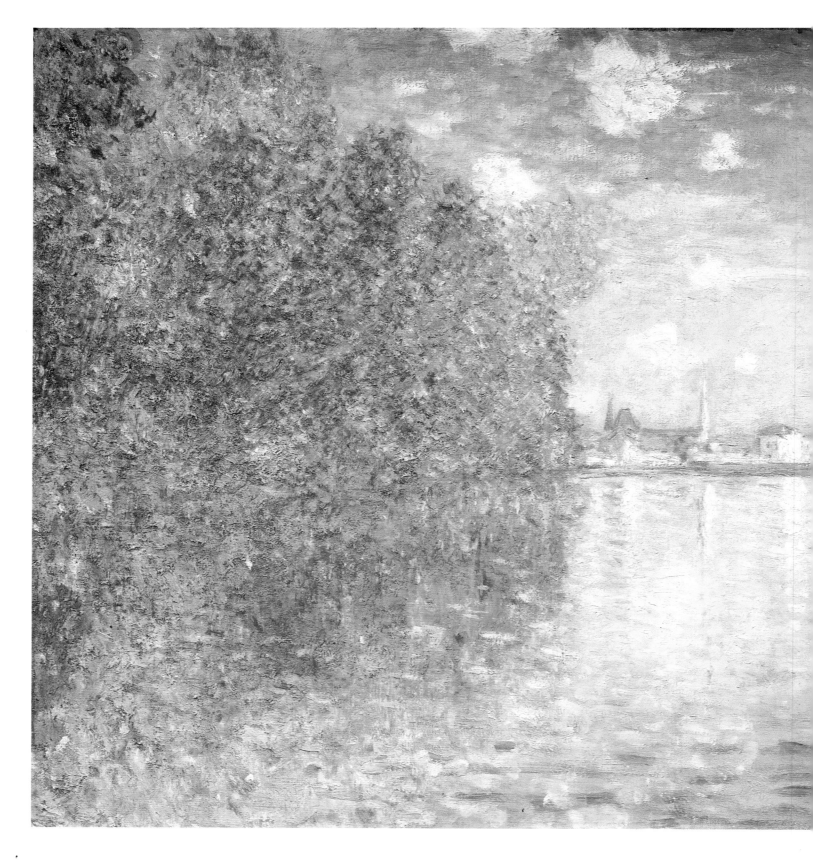

The Seine at Argenteuil, 1872
Oil on canvas, 22×29½ inches (56×75 cm)
Courtauld Institute Galleries, London

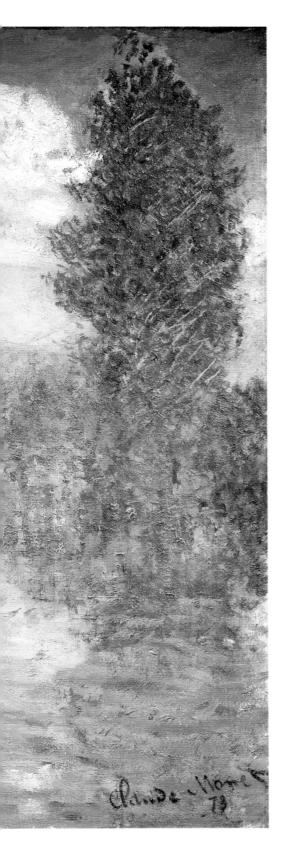

A River Scene, Autumn, *c.*1874
Oil on canvas, 21³⁄₄×25¹⁄₂ inches (55×65 cm)
National Gallery of Ireland, Dublin

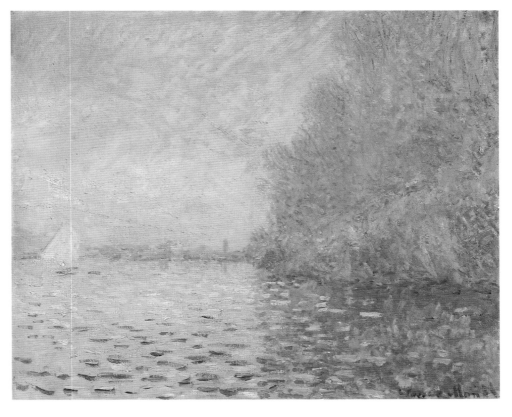

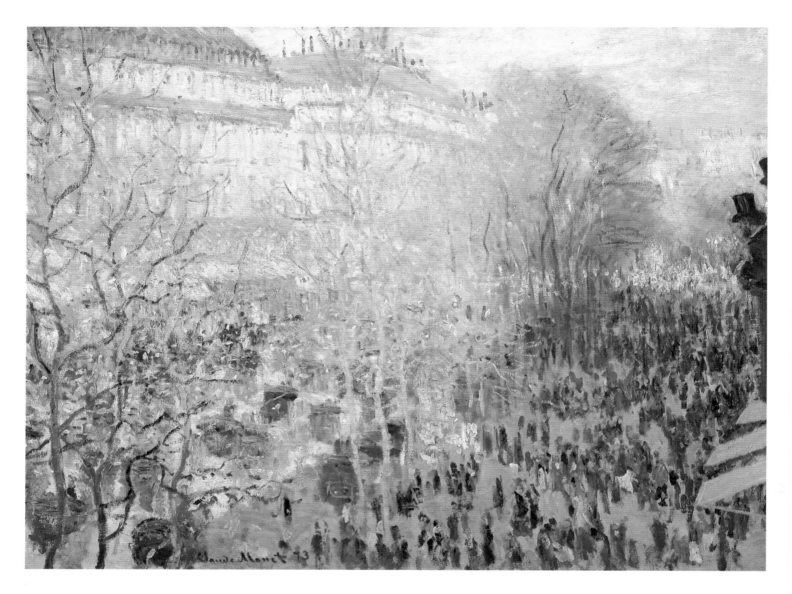

ABOVE
Boulevard des Capucines, 1873
Oil on canvas, 23½×31½ inches (60×80 cm)
Pushkin Museum, Moscow

Boulevard des Capucines, 1873
Oil on canvas, 31½×23¼ inches (80×59 cm)
The Nelson-Atkins Museum of Art, Kansas

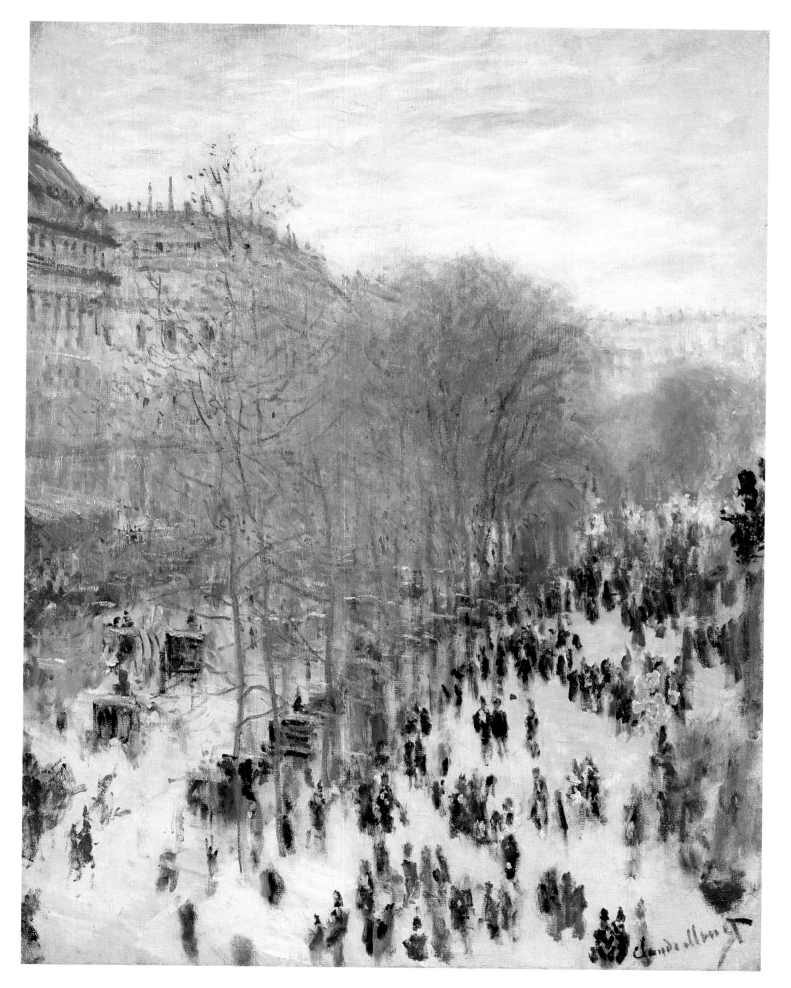

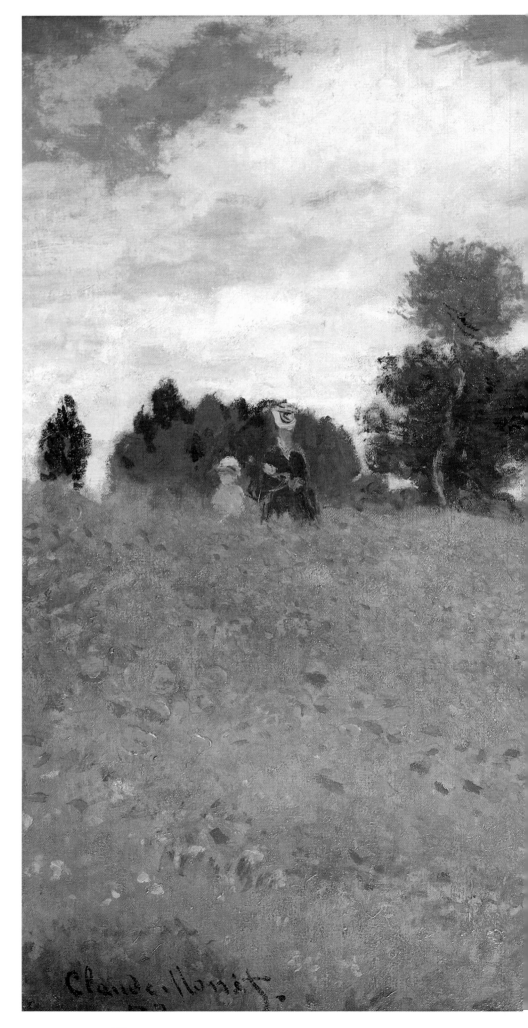

Wild Poppies, 1873
Oil on canvas, 19¾×25½ inches
(50×65 cm)
Musée d'Orsay, Paris

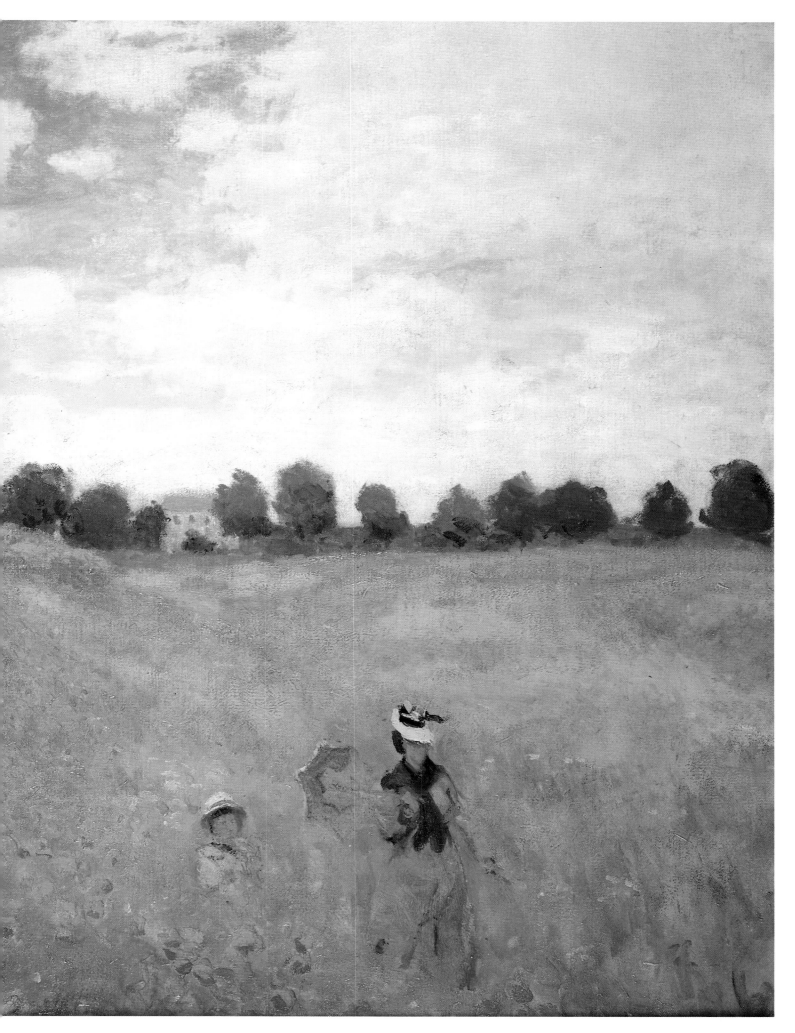

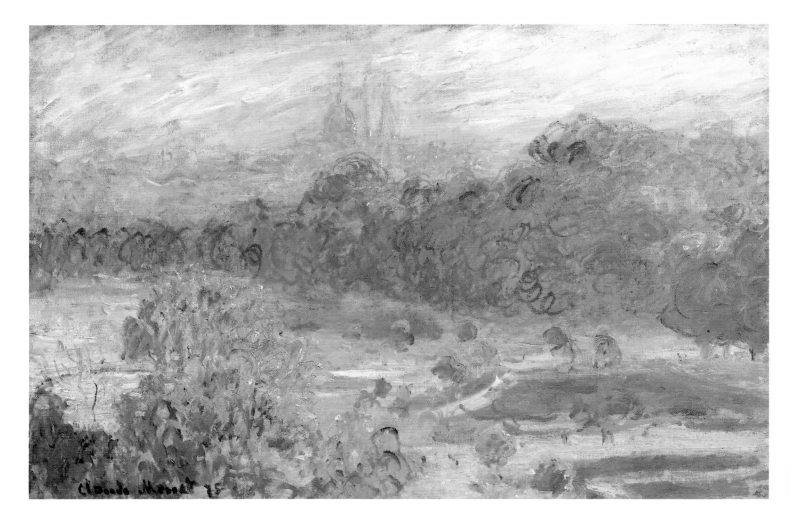

The Tuileries, Etude, 1875
Oil on canvas, 19¾×29½ inches (50×75 cm)
Musée d'Orsay, Paris

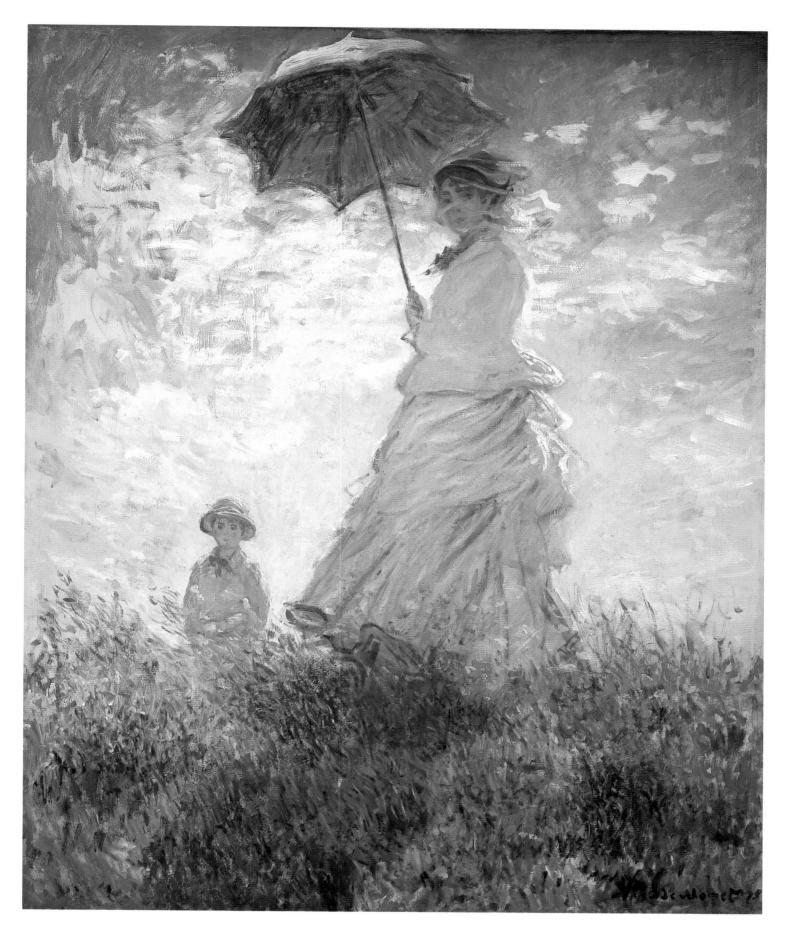

Woman with a Parasol – Madame Monet and her Son, 1875
Oil on canvas, 39½×31¼ inches (100×81 cm)
National Gallery of Art, Washington. Collection of Mr and Mrs Paul Mellon

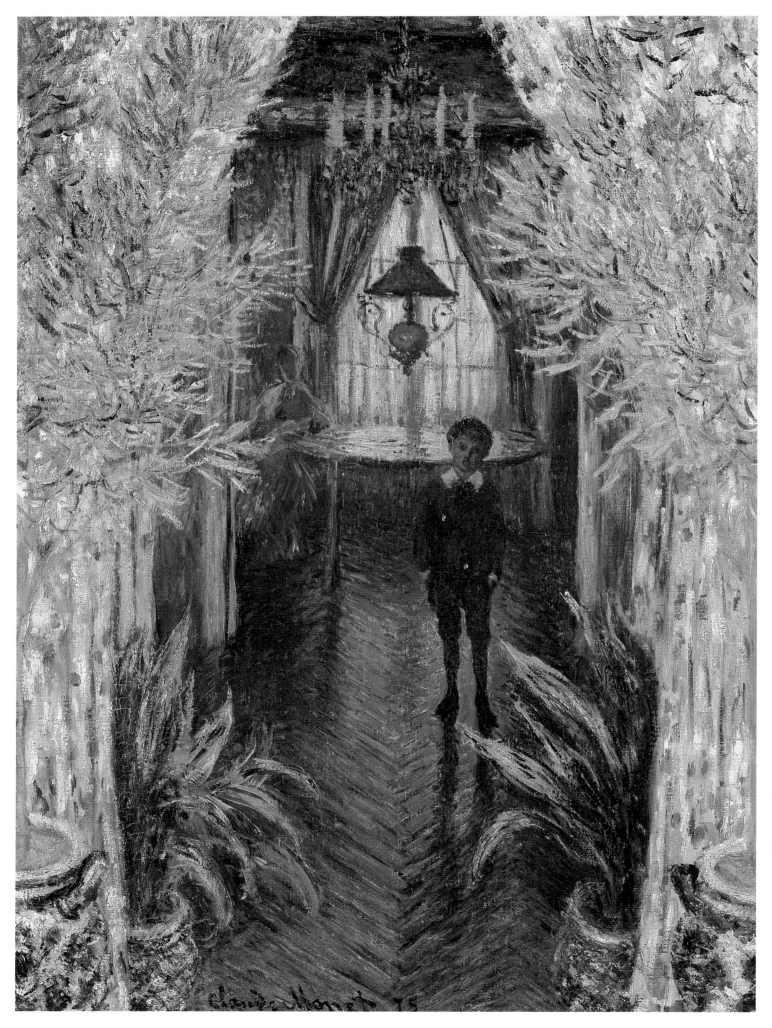

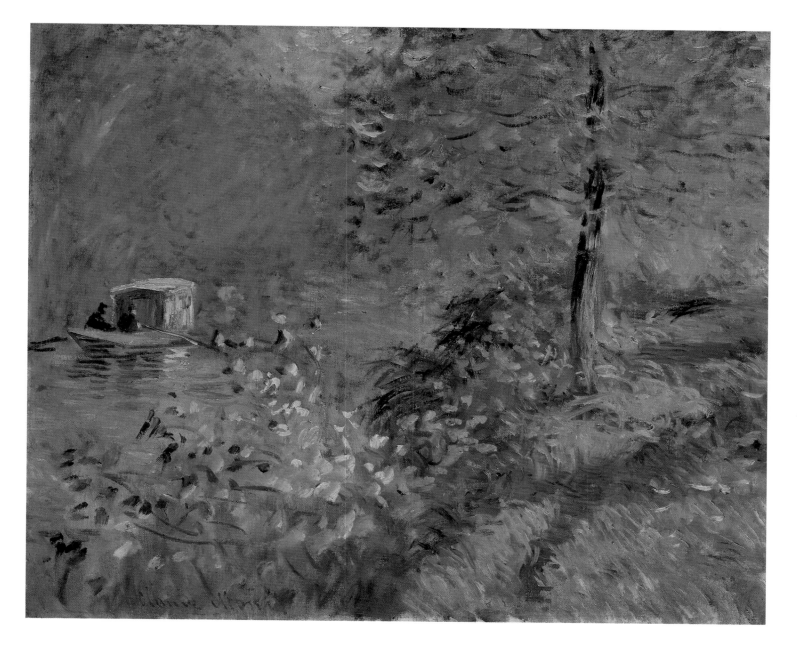

ABOVE
The Studio Boat at Argenteuil, c.1876
Oil on canvas, 21¼×25½ inches (54×65 cm)
Musée d'Art et d'Histoire, Neuchâtel

LEFT
A Corner of the Apartment, 1875
Oil on canvas, 32×23¾ inches (81.5×60.5 cm)
Musée d'Orsay, Paris

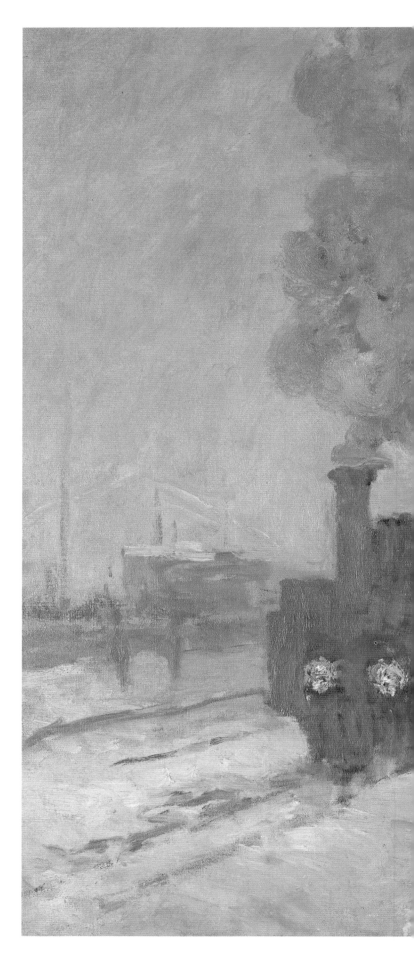

Train in the Snow, 1875
Oil on canvas, 23¼×30¾ inches (59×78 cm)
Musée Marmottan, Paris

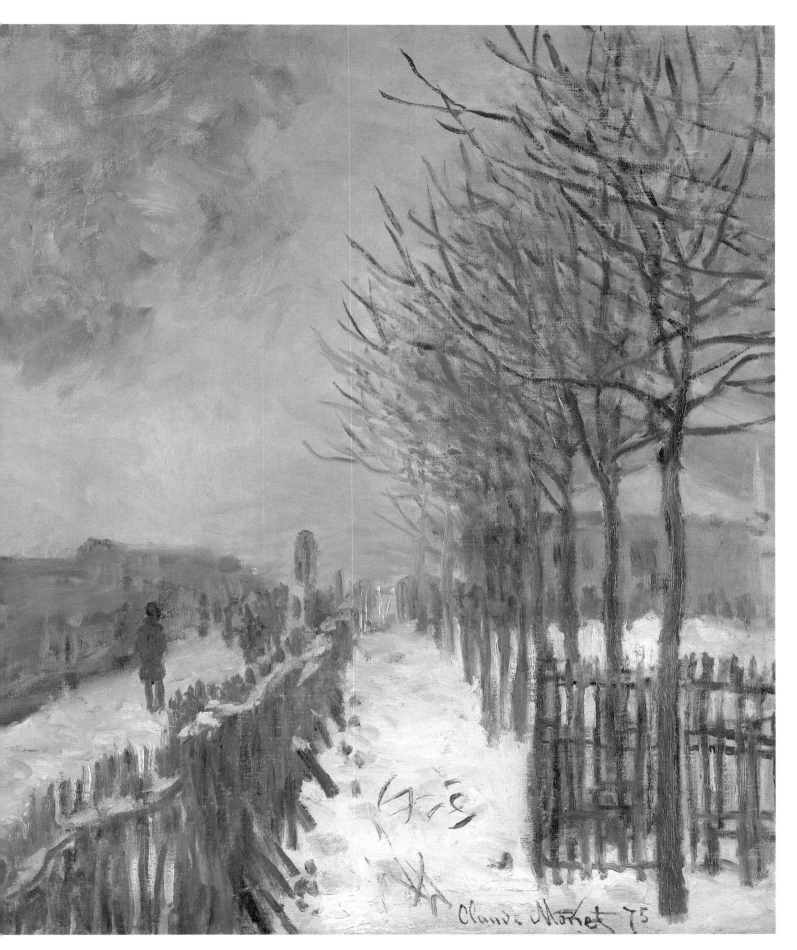

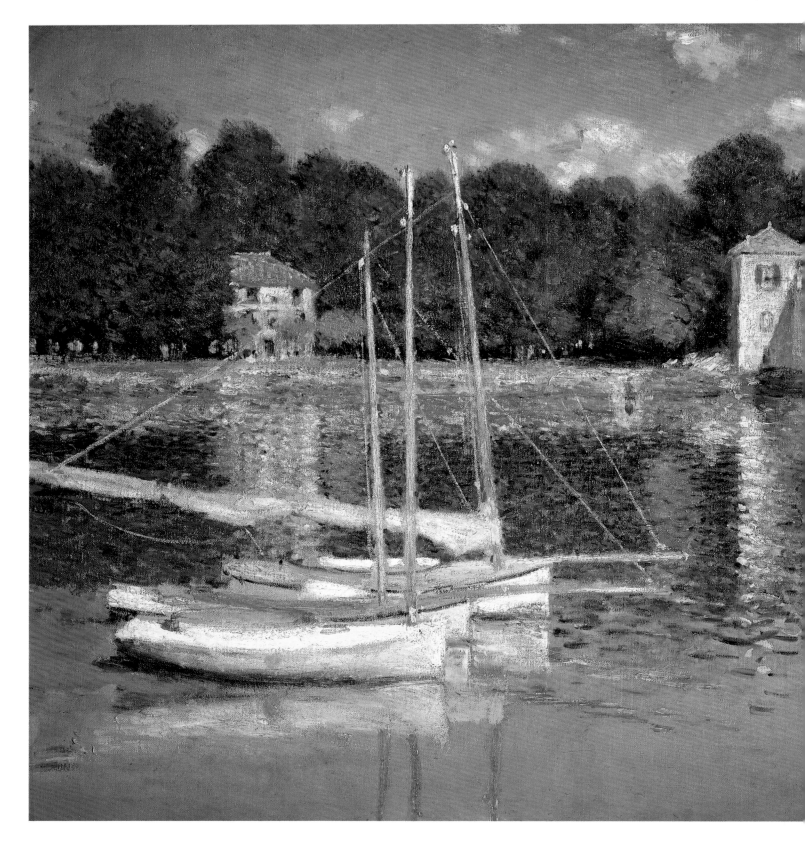

The Bridge at Argenteuil, 1874
Oil on canvas, 23½×31¾ inches (60×80 cm)
Musée du Louvre, Paris

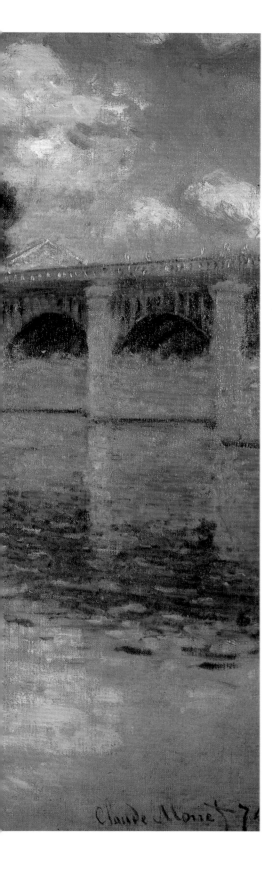

La Japonaise, 1875-76
Oil on canvas, 91¼×56 inches (231.6×142.3 cm)
Museum of Fine Arts, Boston, 1951 Purchase Fund

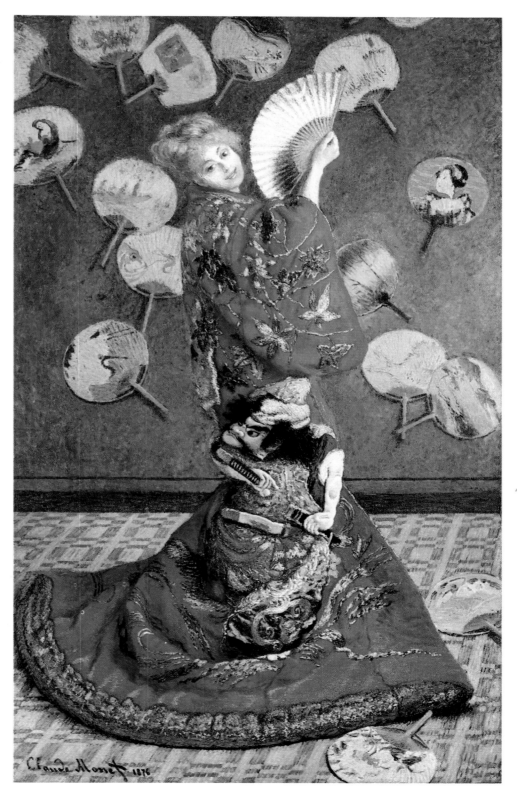

Gladioli, 1876
Oil on canvas, 21¾×32¼ inches (55×82 cm)
Detroit Institute of Arts, Detroit

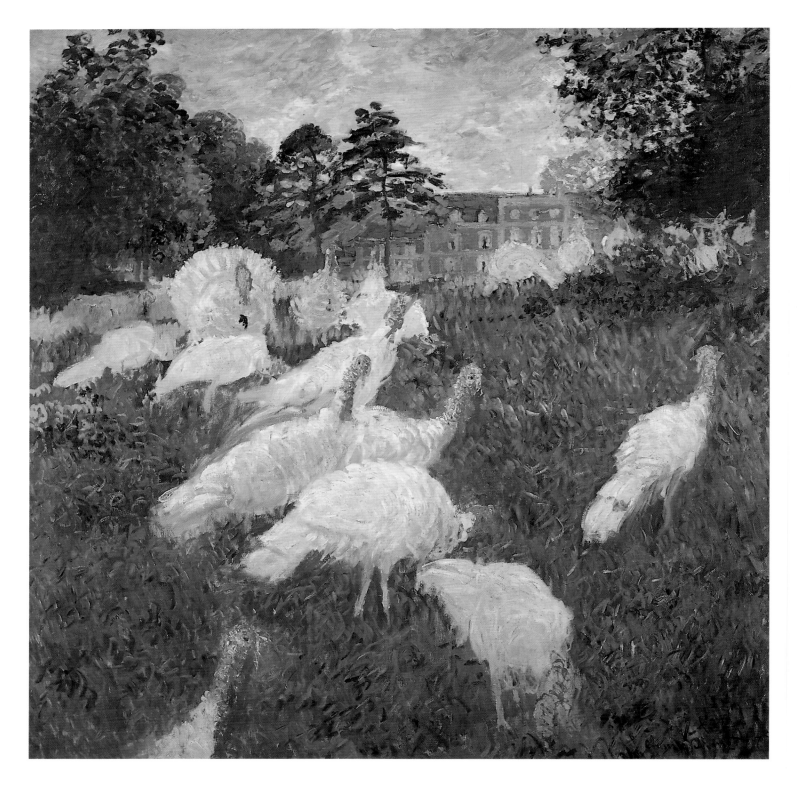

ABOVE
The Turkeys, 1876
Oil on canvas, 67¾×69 inches (172×175 cm)
Musée d'Orsay, Paris

RIGHT
La Rue Montorgueil, La Fête du 30 Juin, 1878
Oil on canvas, 31½×20 inches (80×50.5 cm)
Musée d'Orsay, Paris

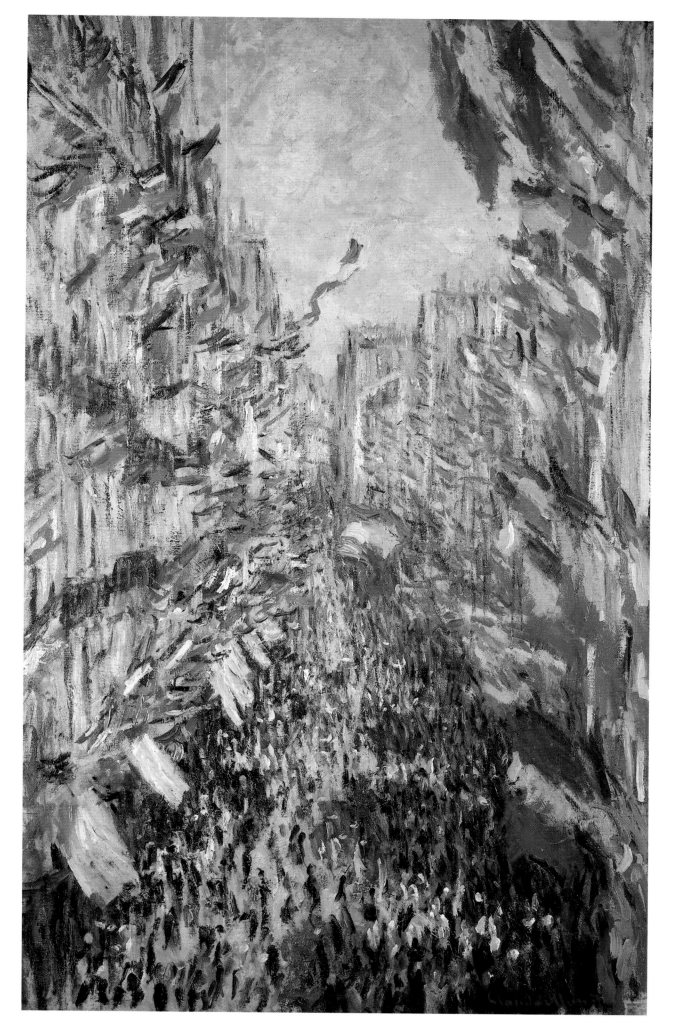

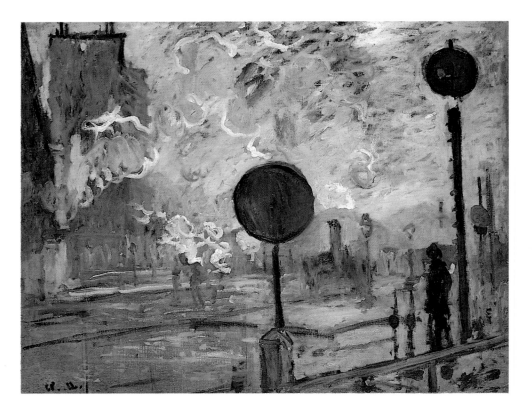

Outside the Gare Saint-Lazare (The Signal), 1877
Oil on canvas, 25¾×32¼ inches (65.5×82 cm)
Niedersächsisches Landesmuseum, Hanover

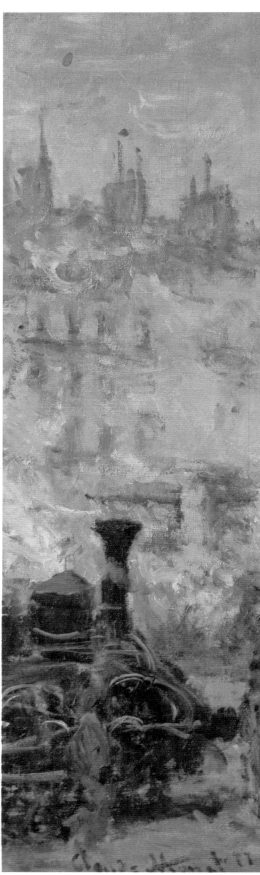

The Pont de l'Europe, 1877
Oil on canvas, 25¹/₄×38 inches (64×81 cm)
Musée Marmottan, Paris

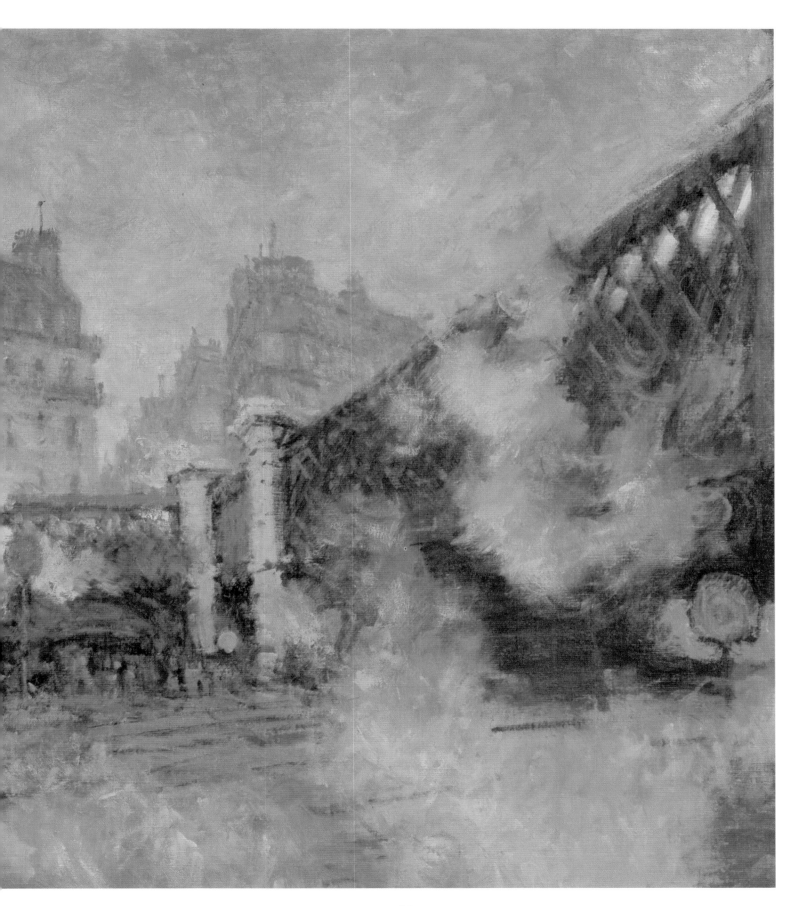

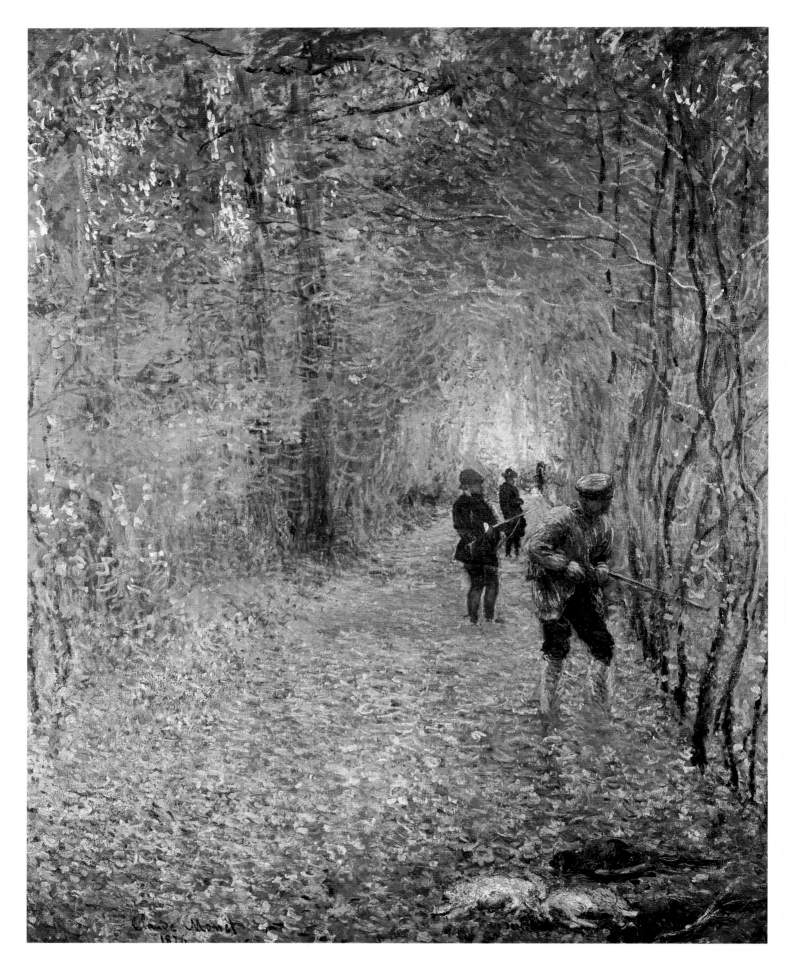

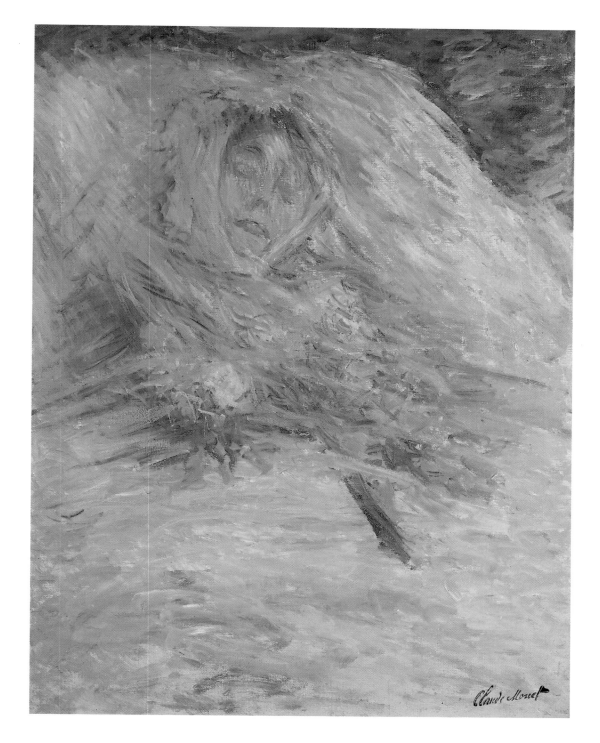

Camille Monet on her Deathbed, 1879
Oil on canvas, 35½×26¾ inches (90×68 cm)
Musée d'Orsay, Paris

The Hunt, 1876
Oil on canvas, 67×54 inches (170×137 cm)
Collection Durand-Ruel, Paris

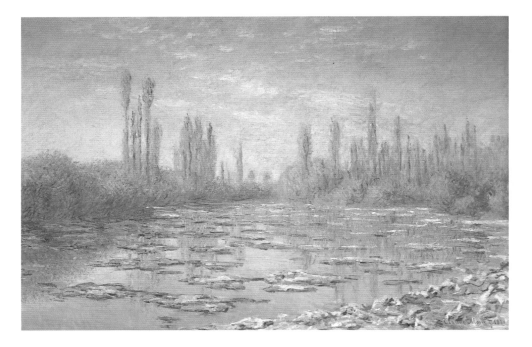

The Ice Floes, 1880
Oil on canvas, 38¼×59 inches (97×150 cm)
Shelburne Museum, Shelburne, Vermont

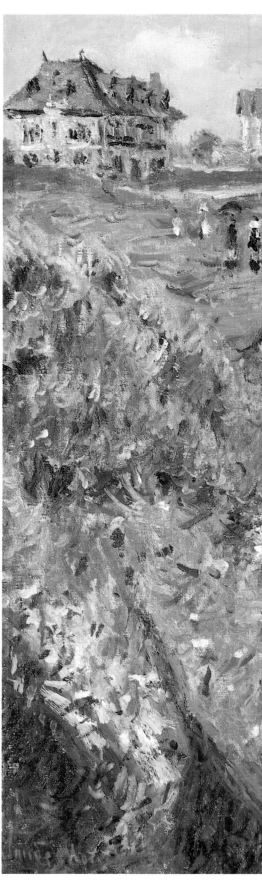

Cliff at Dieppe, 1882
Oil on canvas, 25½×32 inches (65×81 cm)
Kunsthaus, Zurich

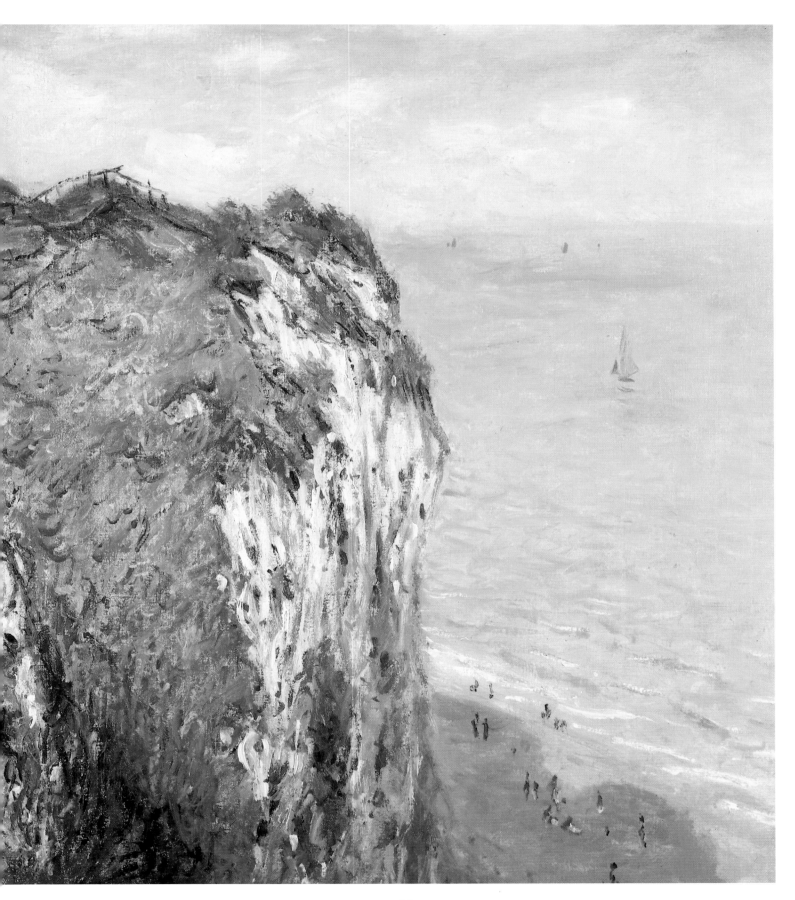

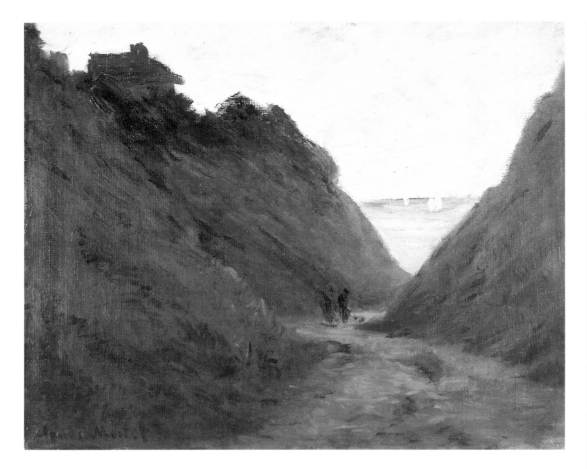

ABOVE
Sunken Pathway in the Cliffs at Varengueille, 1882
Oil on canvas, 23½×28¾ inches (60×73 cm)
Walsall Art Gallery, England

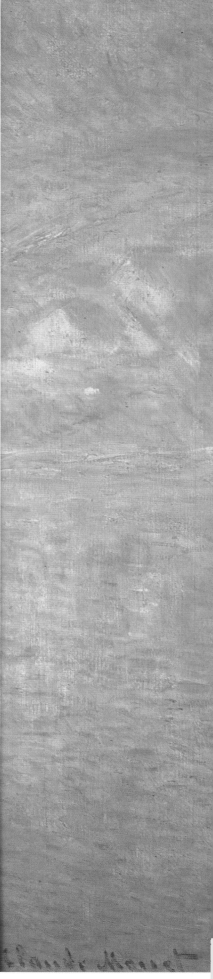

<div align="right">
RIGHT
Véthueil, Setting Sun, 1879
Oil on canvas, 27½×28 inches (70×71 cm)
Musée d'Orsay, Paris
</div>

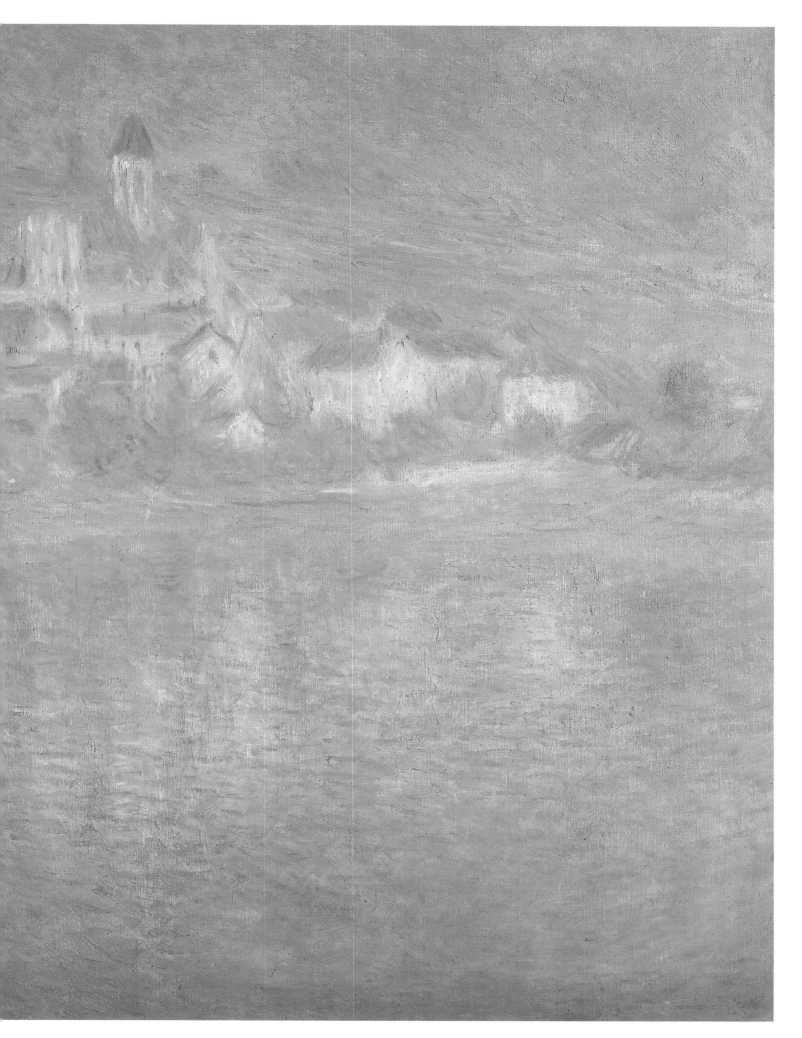

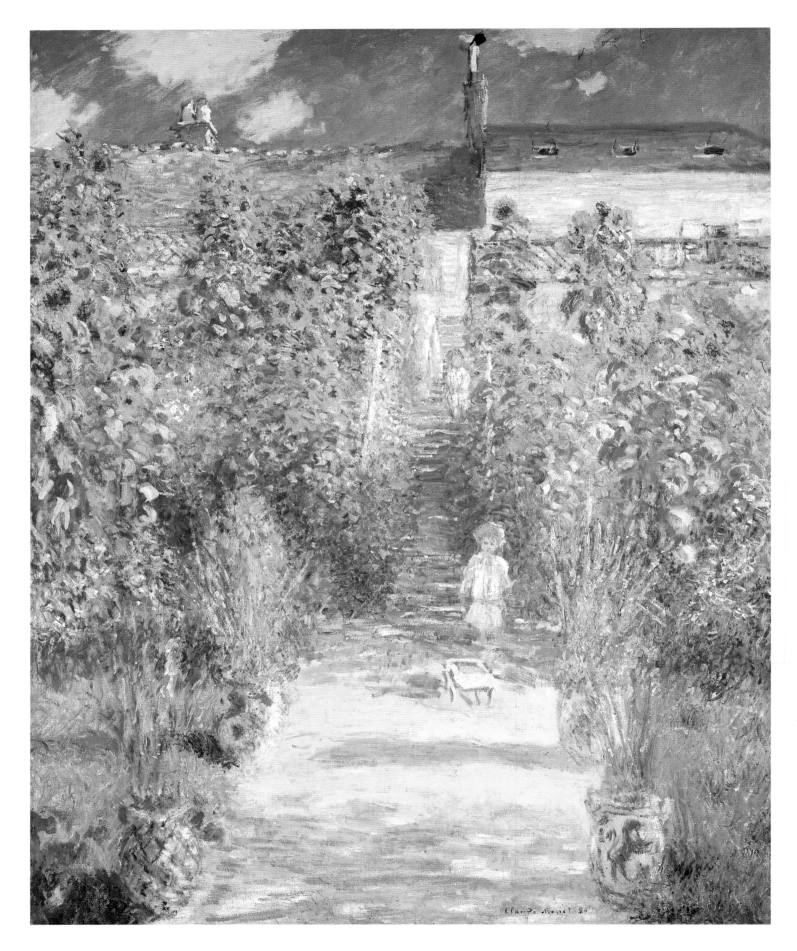

The Artist's Garden at Vétheuil, 1880
Oil on canvas, 59¾×47¾ inches (151.4×121 cm)
National Gallery of Art, Washington, Ailsa Mellon Bruce Collection

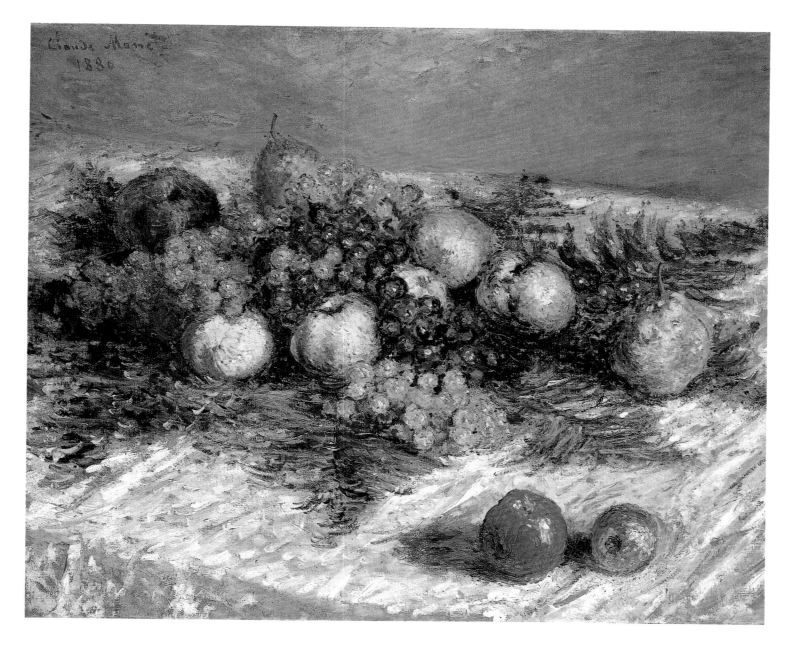

Pears and Grapes, 1880
Oil on canvas, 25¼×31½ inches (65×81 cm)
Kunsthalle, Hamburg

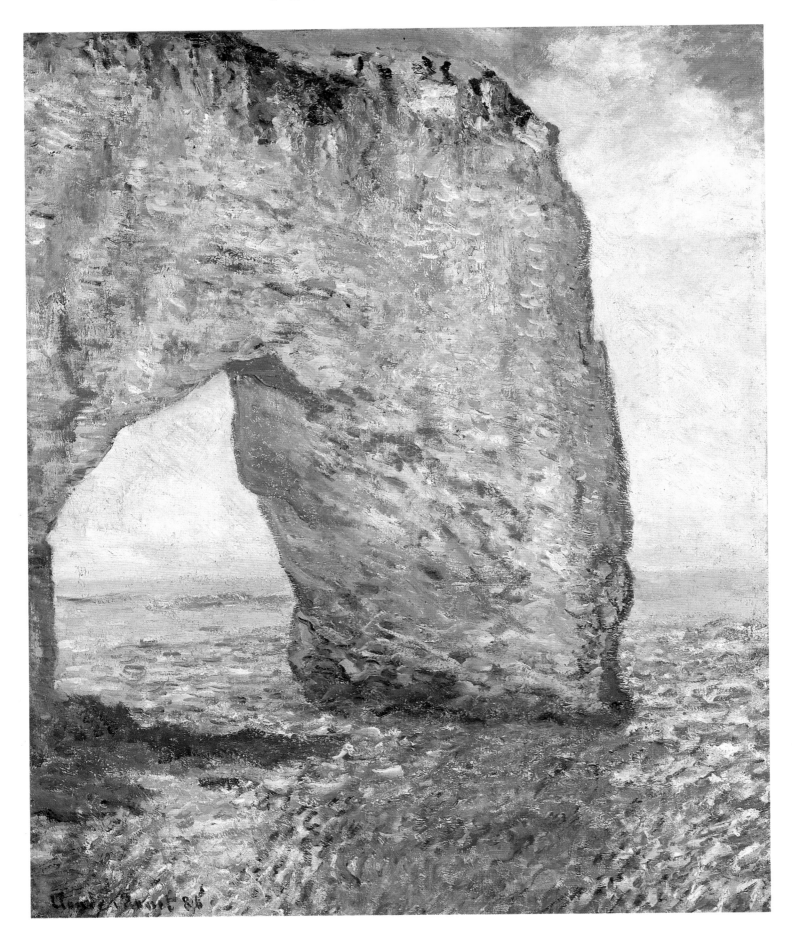

The Manneporte, 1886
Oil on canvas, 32×25¾ inches (81.3×65.4 cm)
Metropolitan Museum of Art. New York. Bequest of Lillie P Bliss. 1931

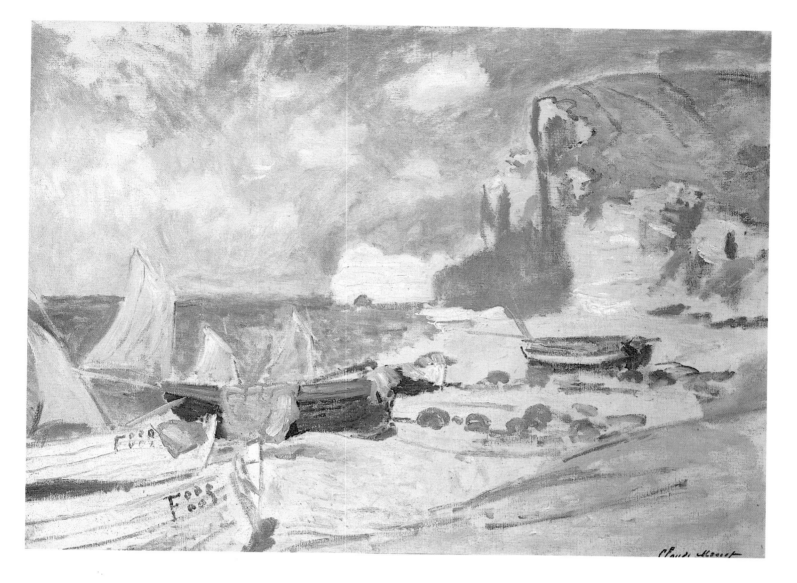

Fishing Boats, Etretat, *c.*1885
Oil on canvas, 23¾×32 inches (60×81 cm)
Musée Eugène Boudin, Honfleur

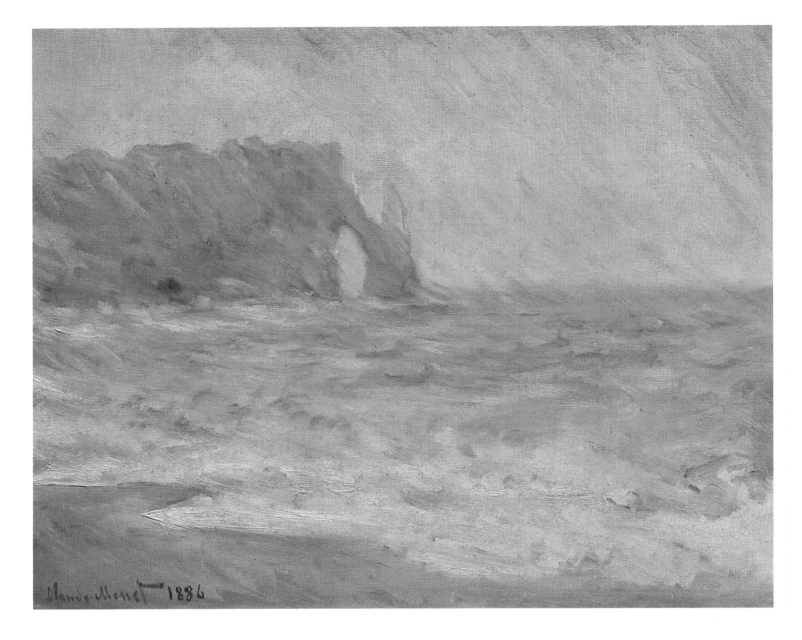

Rain, Etretat, 1885 (dated 1886)
Oil on canvas, 23¾×29 inches (60.5×73.5 cm)
Nasjonalgalleriet, Oslo

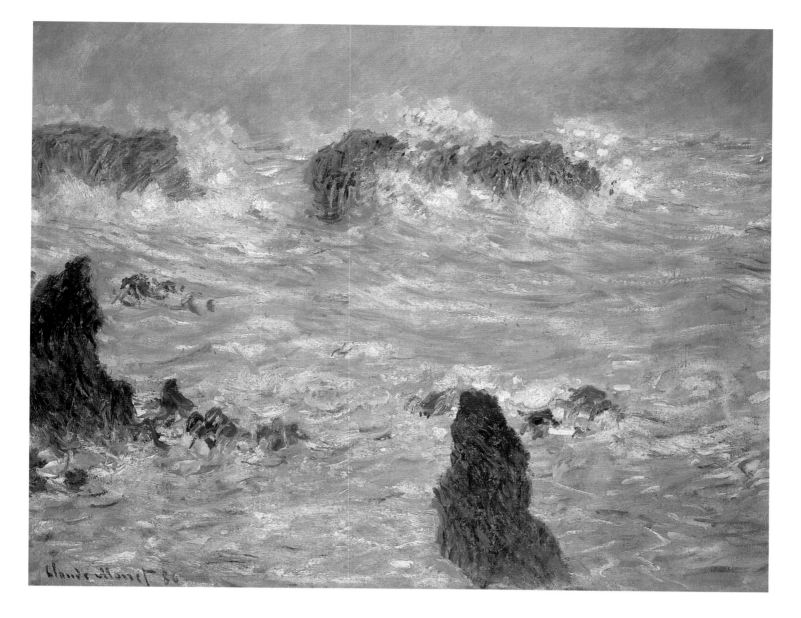

Tempest, Coast of Belle-Ile, 1886
Oil on canvas, 25½×32 inches (65×81 cm)
Musée d'Orsay, Paris

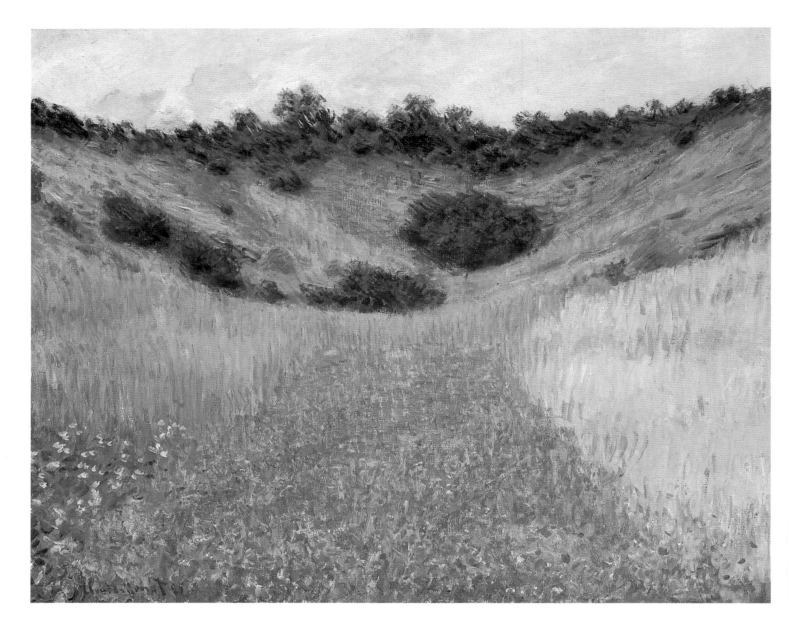

Poppy Field near Giverny, 1885
Oil on canvas, 25½×32 inches (65×81 cm)
Museum of Fine Arts, Boston, bequest of Robert J Edwards
and gift of Hannah Mary Edwards and Grace M Edwards in
memory of their mother

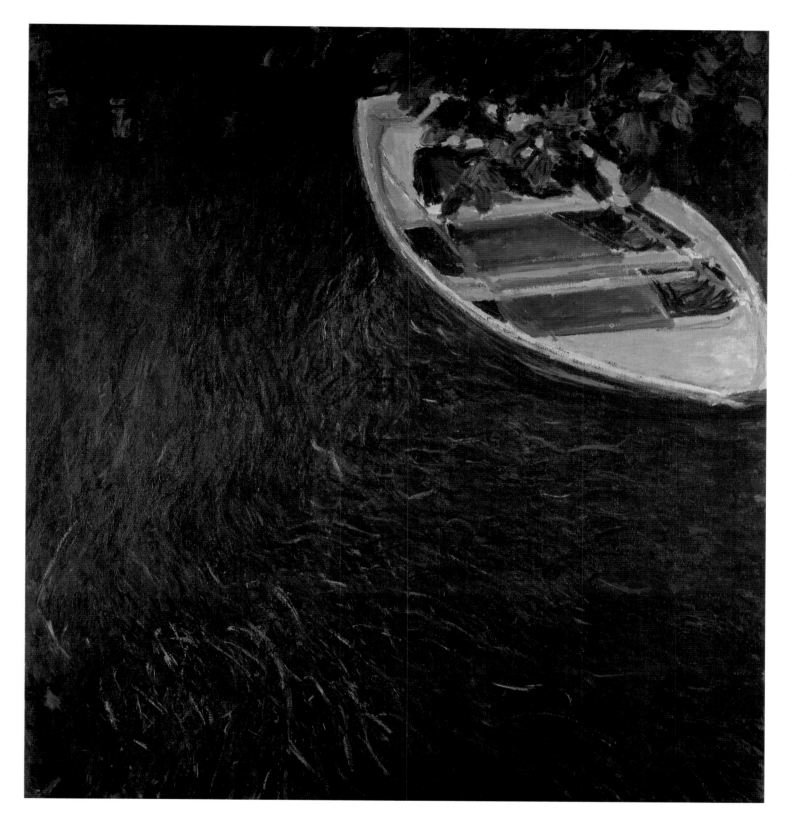

The Boat, 1887
Oil on canvas, 57½×52¼ inches (146×133 cm)
Musée Marmottan, Paris

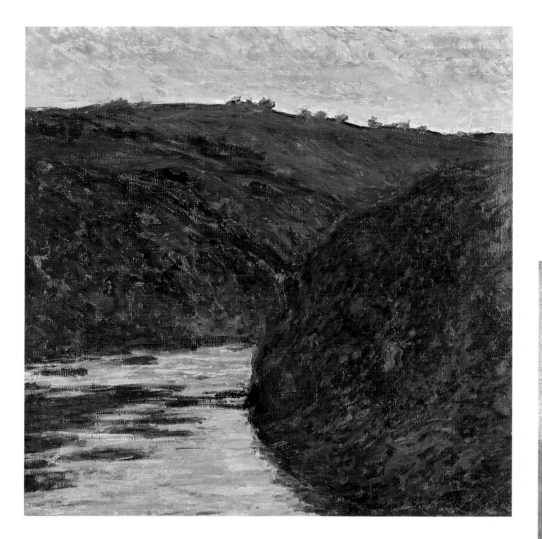

Valley of the Creuse, Sunset, 1889
Oil on canvas, 27½×28¾ inches (70×73 cm)
Musée d'Unterlinden, Colmar

Grainstack (Snow Effect), 1891
Oil on canvas, 25¾×36⅜ inches (65.4×92.3 cm)
Museum of Fine Arts, Boston, gift of Misses Aimée and Rosamond Lamb
in memory of Mr and Mrs Horatio Lamb

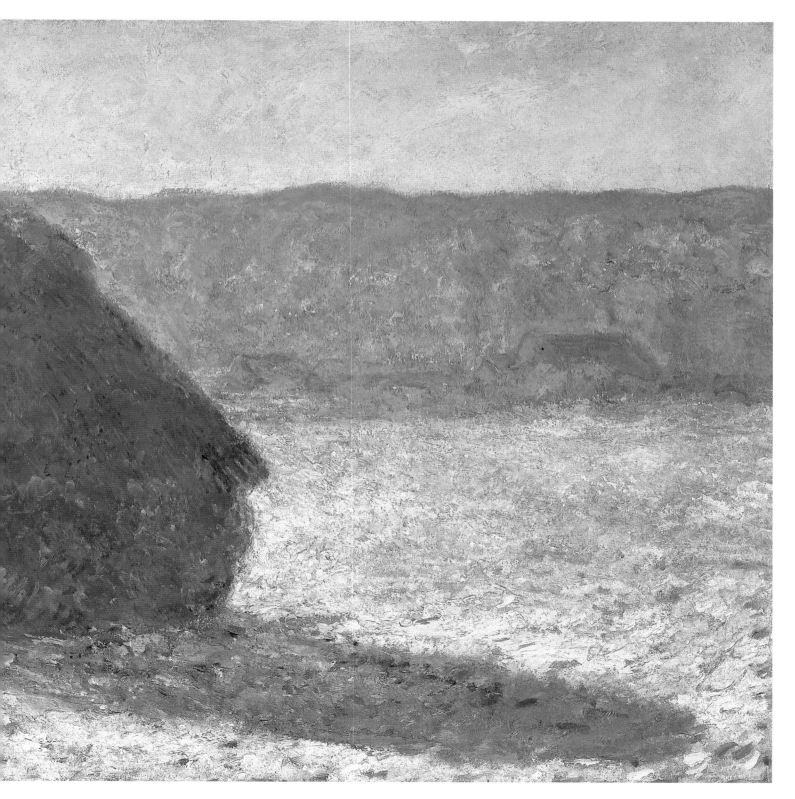

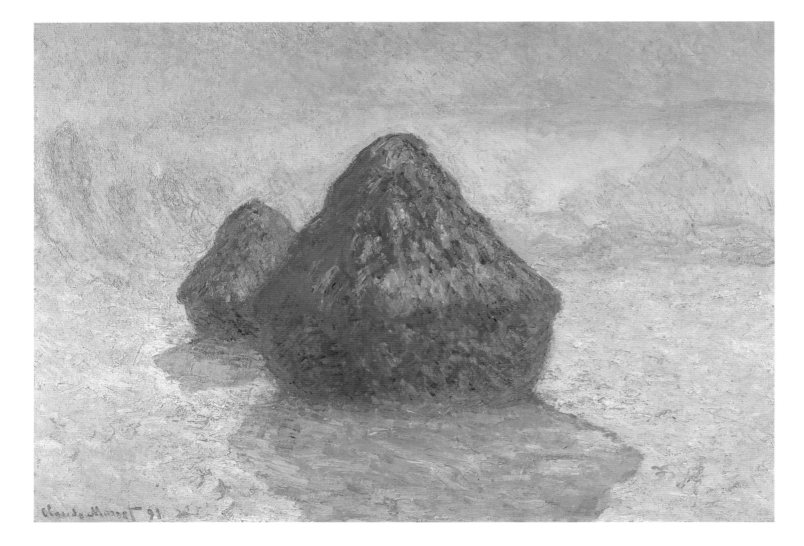

Haystacks: Snow Effect, 1891
Oil on canvas, 25¹/₄×36¹/₄ inches (65×81 cm)
National Gallery of Scotland, Edinburgh

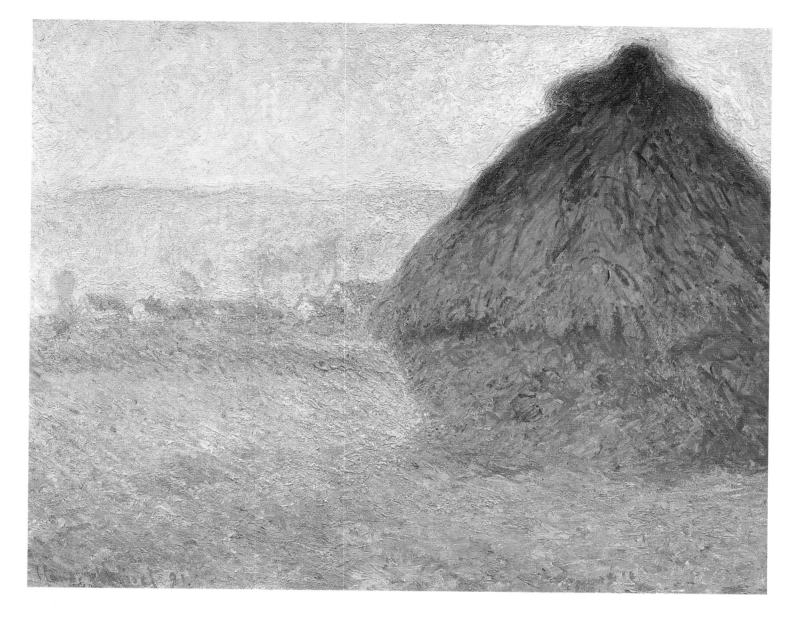

Grain Stacks at Sunset, 1891
Oil on canvas, 25³/₄×36¹/₂ inches (73.3×92.6 cm)
Museum of Fine Arts, Boston. Julia Cheney Edwards Collection

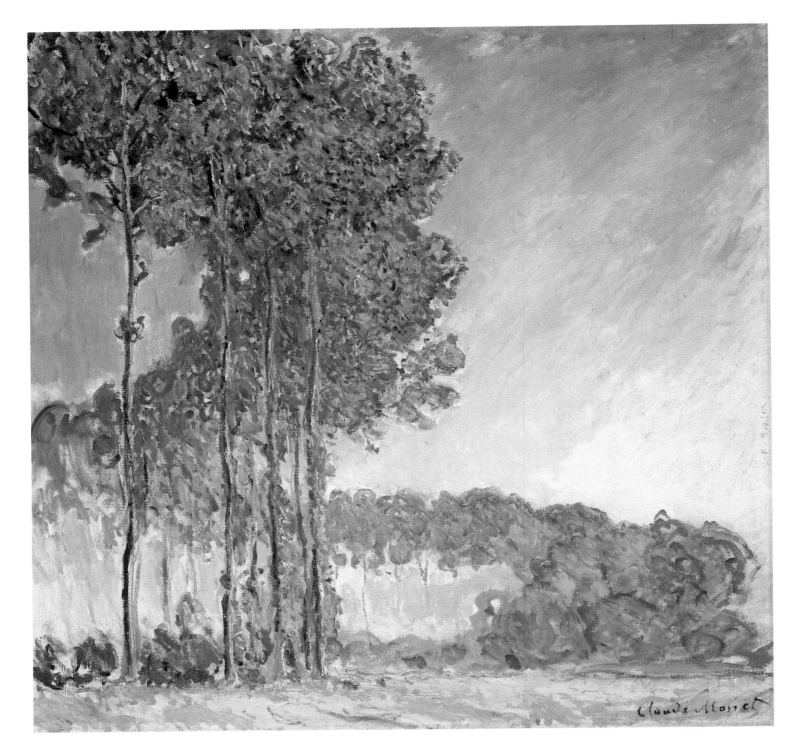

Poplars, 1891
Oil on canvas, 35½×36½ inches (90×93 cm)
Fitzwilliam Museum, Cambridge

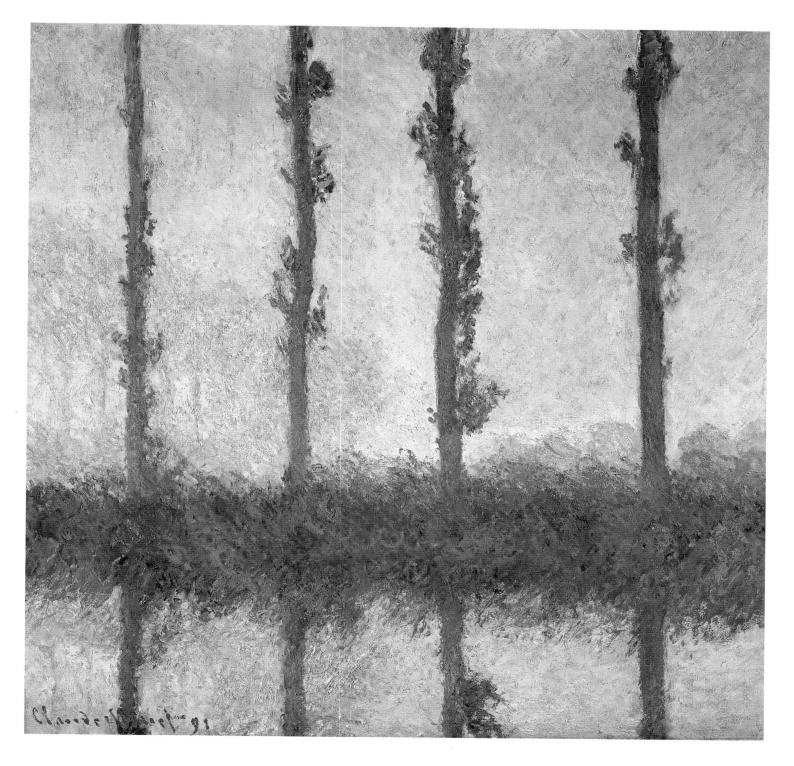

The Four Poplars, 1891
Oil on canvas, 32¼×32⅛ inches (81.9×81.6 cm)
Metropolitan Museum of Art, New York.
Bequest of Mrs H O Havemeyer, 1929.
The Havemeyer Collection (29.100.110)

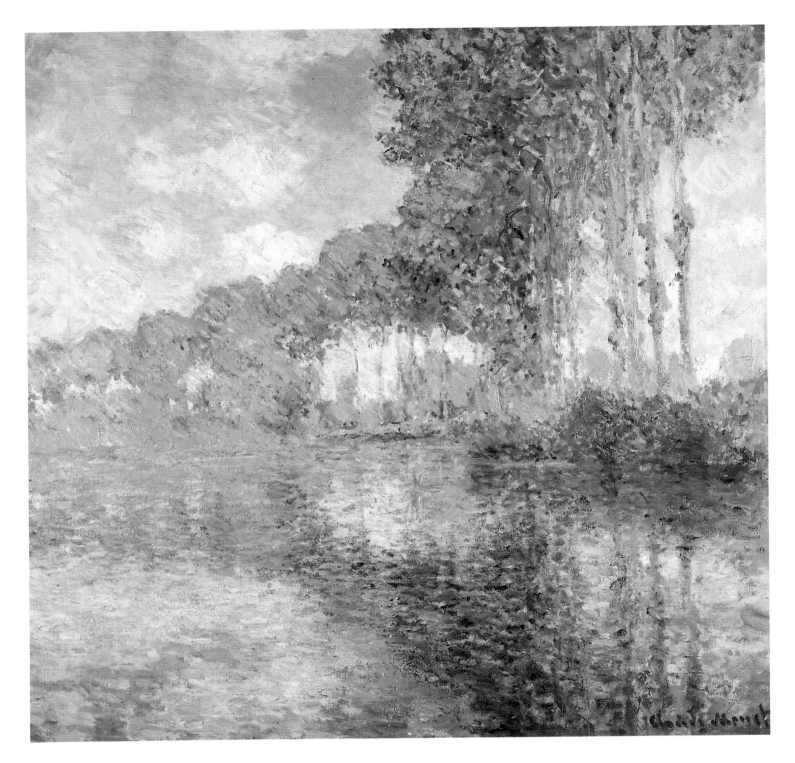

ABOVE
Poplars on the Epte, 1891
Oil on canvas, 32¼×32 inches (81.9×81.3 cm)
National Gallery of Scotland, Edinburgh

Rouen Cathedral – The Portal and the Tour Saint-Romain,
Full Sunlight: Harmony in Blue and Gold, 1894
Oil on canvas, 42×28¾ inches (107×73 cm)
Musée d'Orsay, Paris

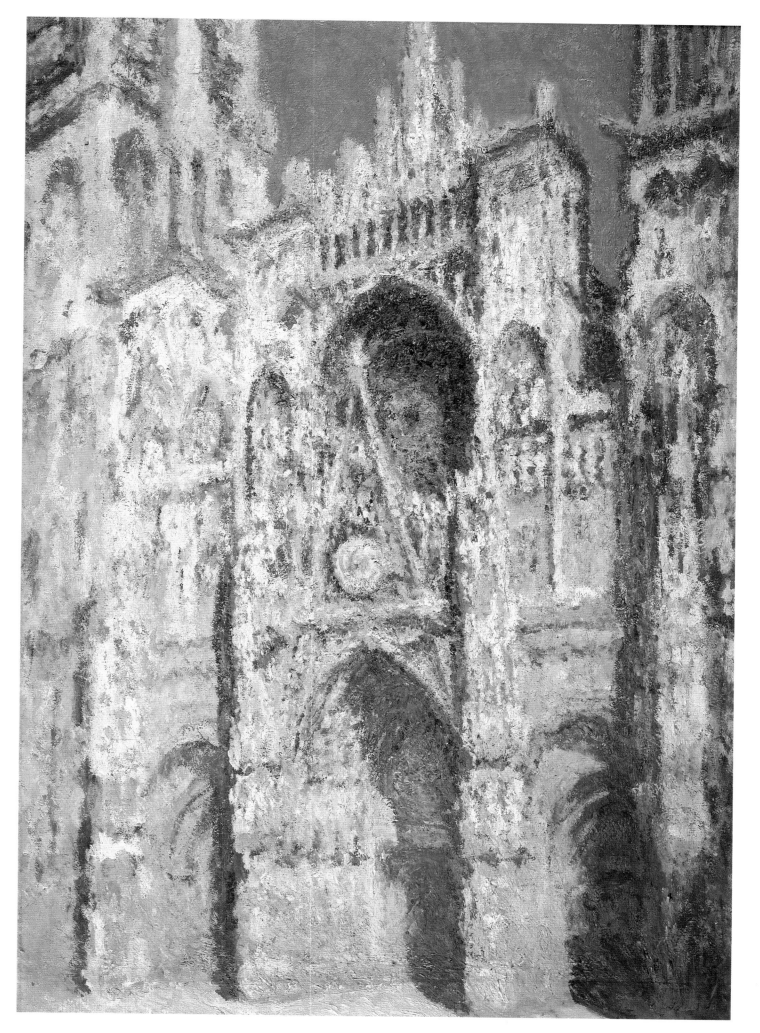

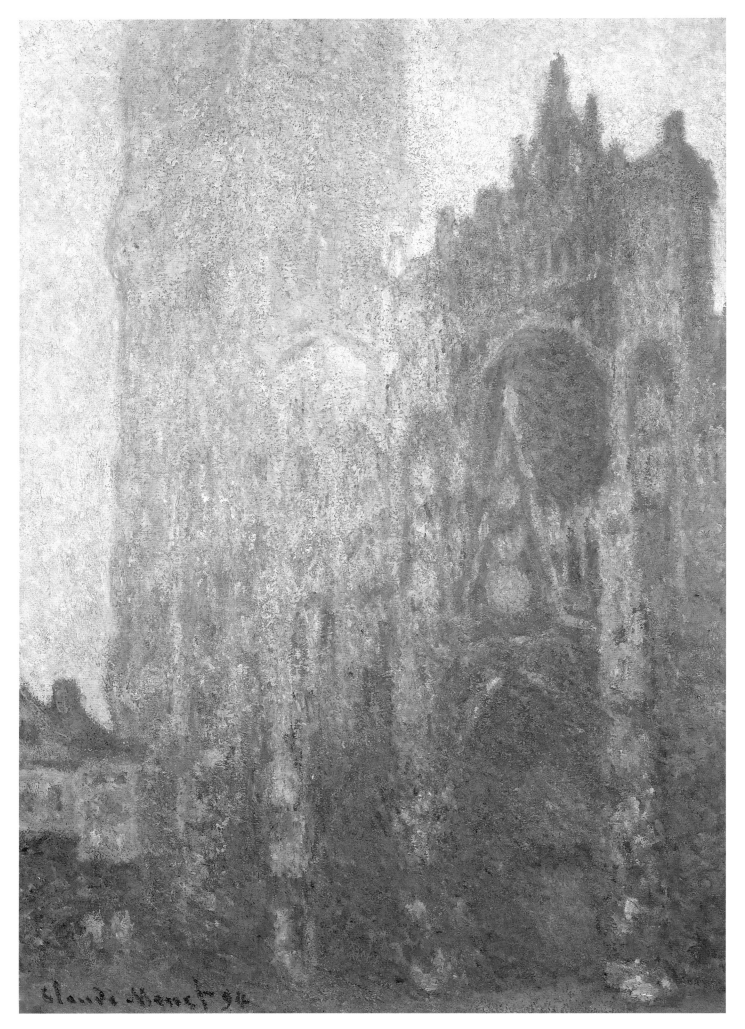

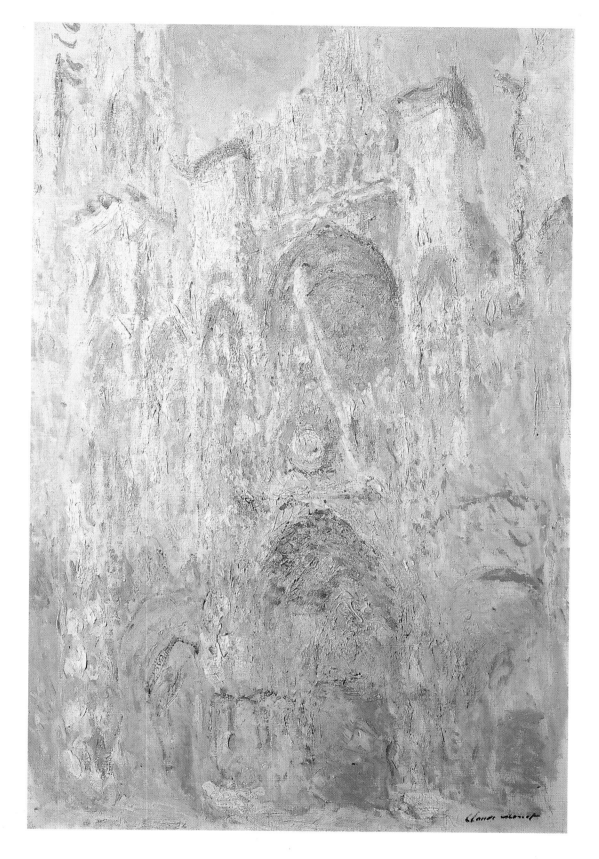

Rouen Cathedral, Façade, 1894
Oil on canvas, 39×26 inches (100×66 cm)
National Gallery of Wales, Cardiff

LEFT
Rouen Cathedral Façade and Tour d'Albane,
(Morning Effect), 1894
Oil on canvas, 41³/₄×29¹/₈ inches (106.1×73.9 cm)
Museum of Fine Arts, Boston, Tompkins Collection

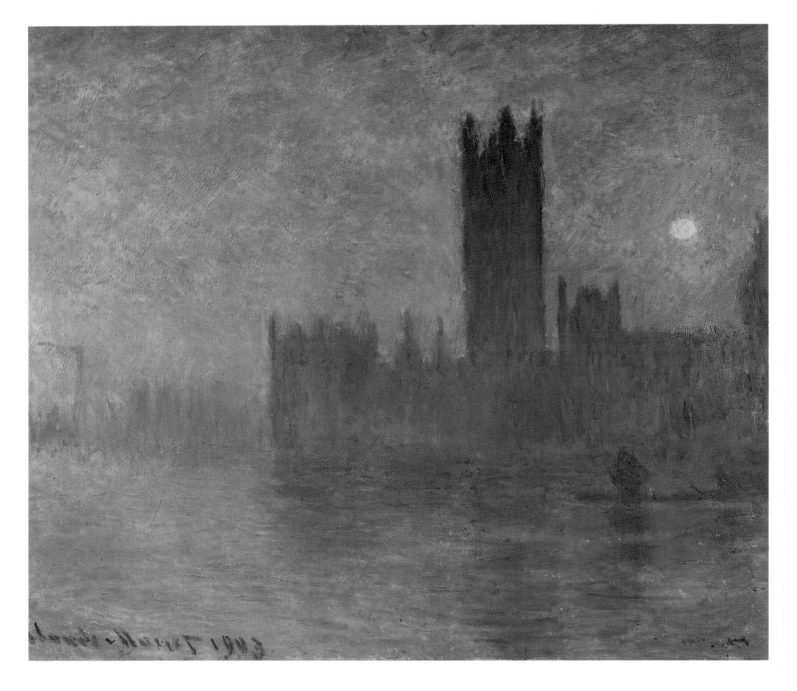

London: Houses of Parliament, Sunset, 1903
Oil on canvas, 30×36 inches (76.2×91.4 cm)
Private Collection

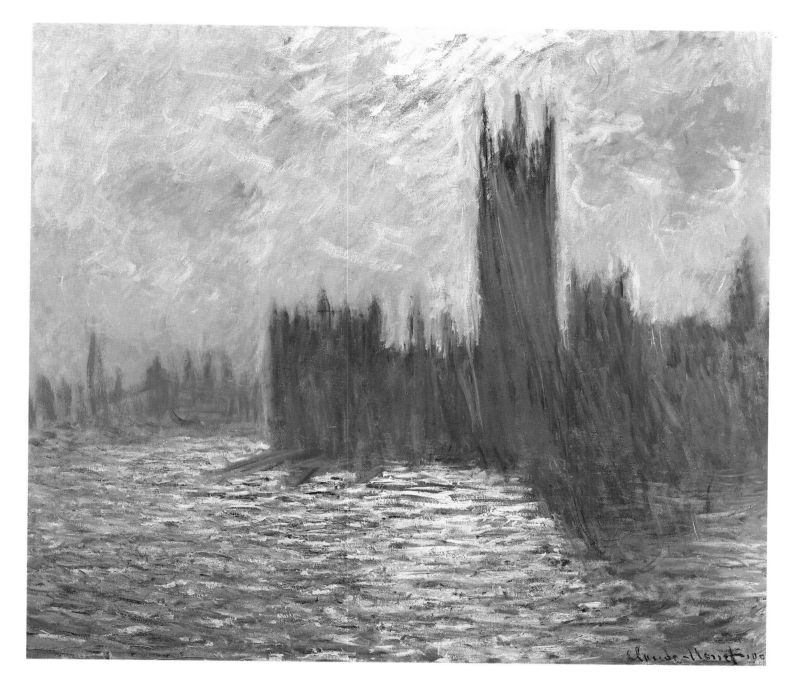

London, Houses of Parliament, 1905
Oil on canvas, 31¾×36¼ inches (81×92 cm)
Musée Marmottan, Paris

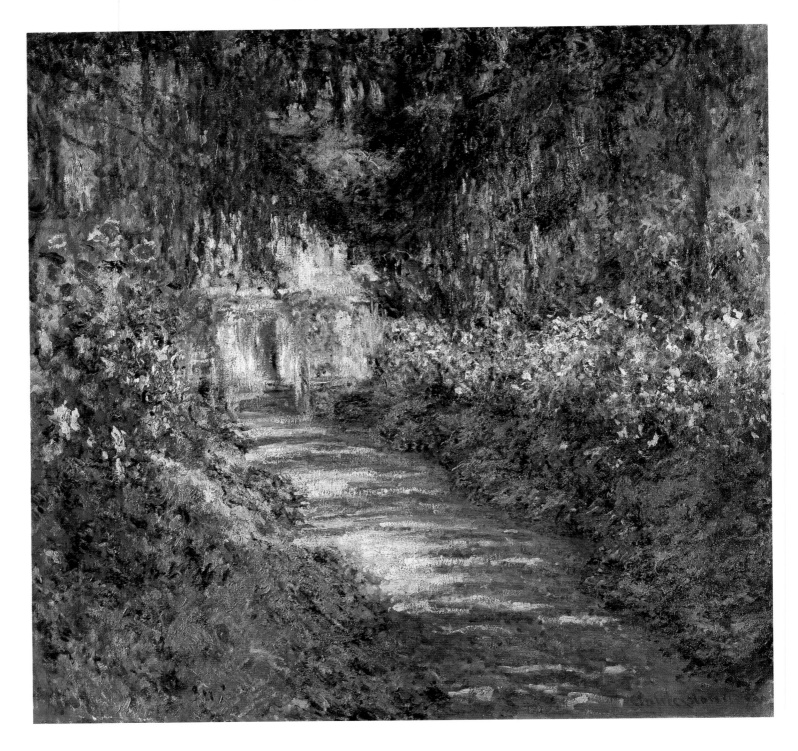

The Garden in Flower, 1900
Oil on canvas, 35×36¼ inches (89×92 cm)
Private Collection

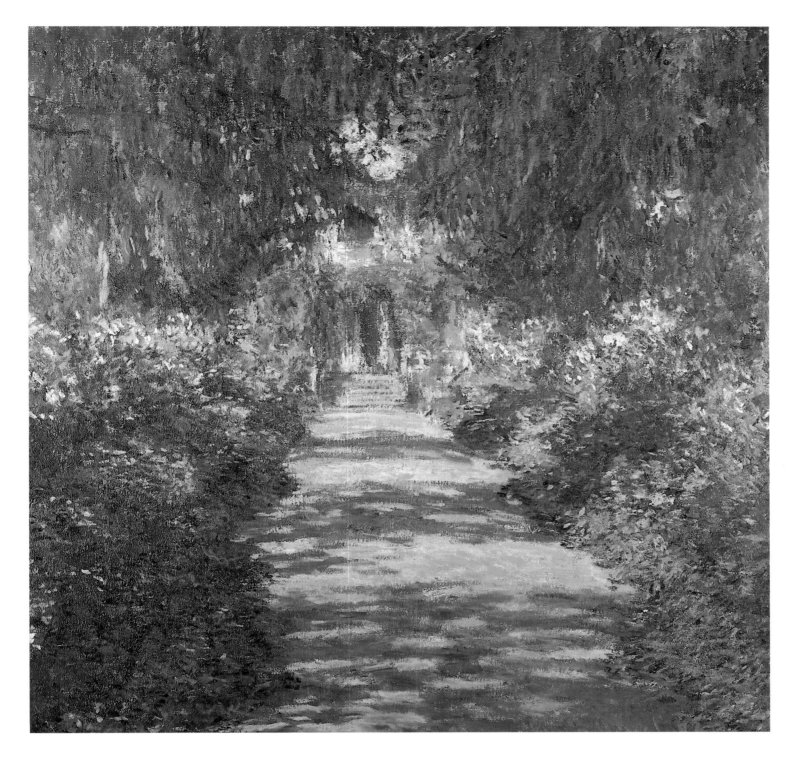

Pathway in Monet's Garden, 1902
Oil on canvas, 35×36¼ inches (89×92 cm)
Osterreichische Galerie, Vienna

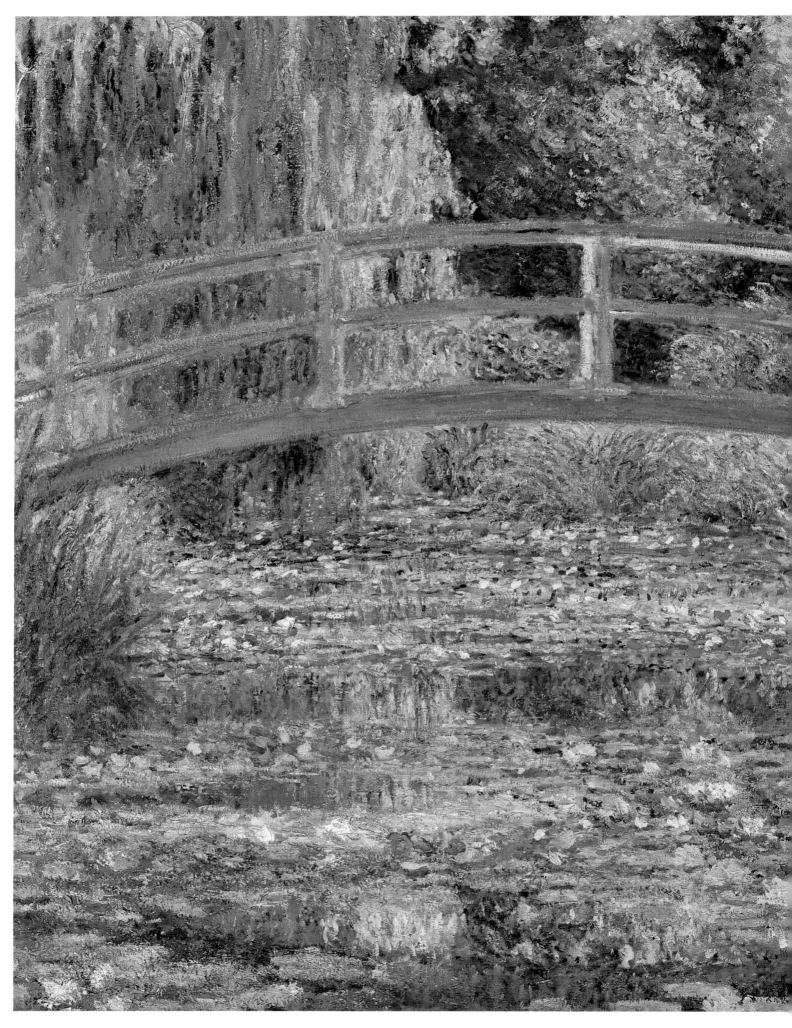

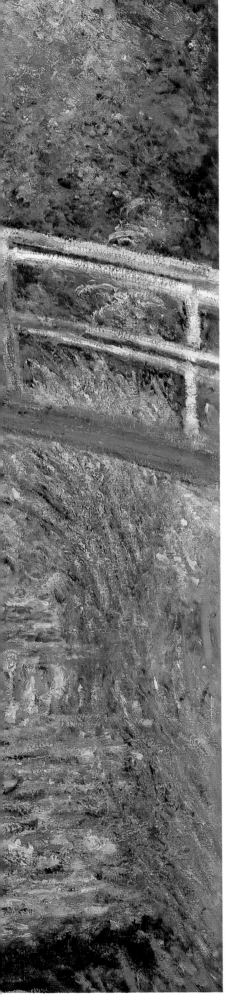

The Japanese Bridge (Le Bassin aux Nymphéas), 1899
Oil on canvas, 34¾×36¼ inches (88.2×92 cm)
The National Gallery, London

BELOW
Waterlilies, 1904
Oil on canvas, 35½×35¾ inches (90×92 cm)
Musée des Beaux-Arts, Caen

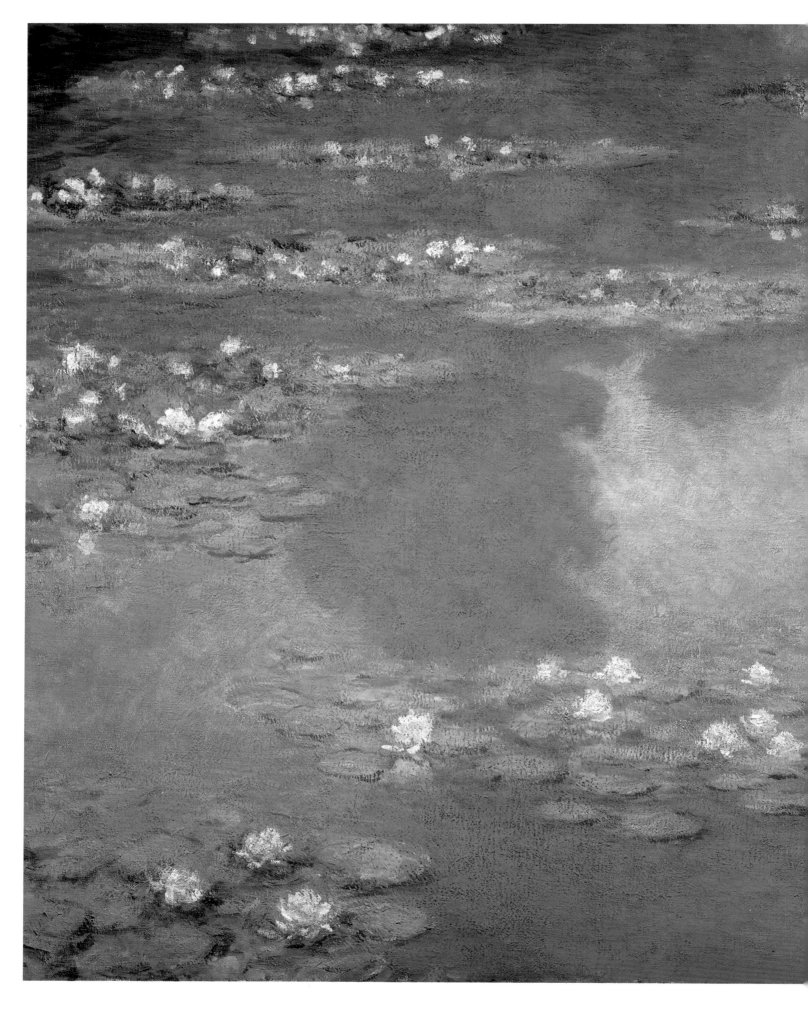

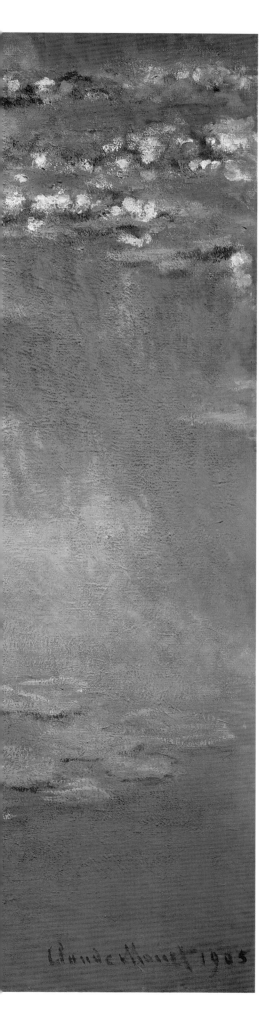

Waterlilies, 1905
Oil on canvas, 34¾×39 inches (89×100 cm)
Museum of Fine Arts, Boston, gift of Edward Jackson Holmes

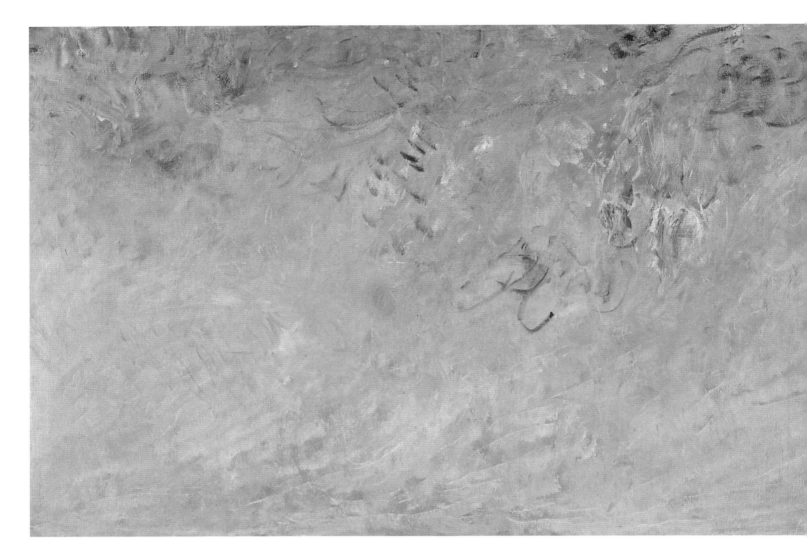

ABOVE
Wisteria, *c.*1920
Oil on canvas, 39¼×118 inches (100×300 cm)
Musée Marmottan, Paris

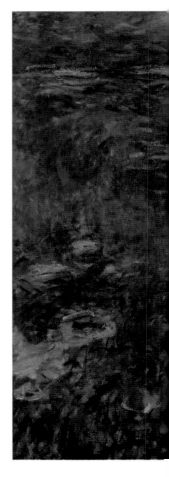

RIGHT
Clouds (detail), *c.*1914-18
Oil on canvas, 78¾×167½ inches (200×425 cm)
Musée de l'Orangerie, Paris

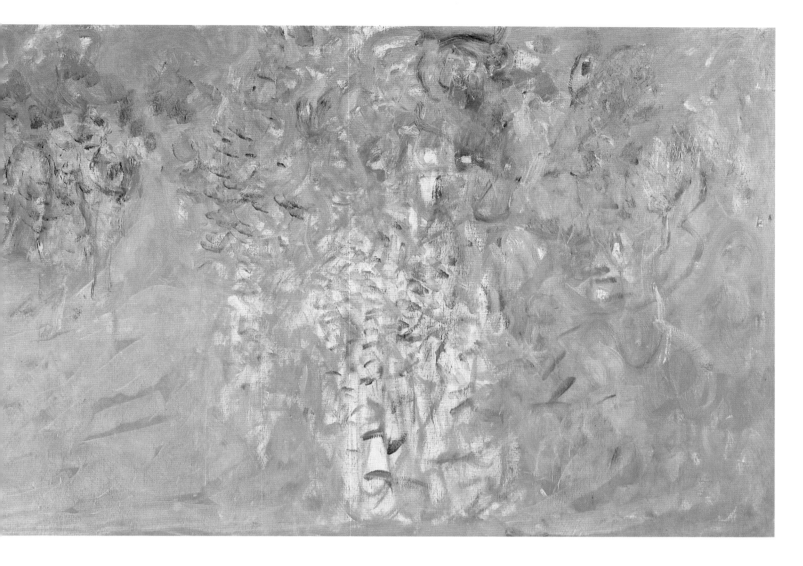

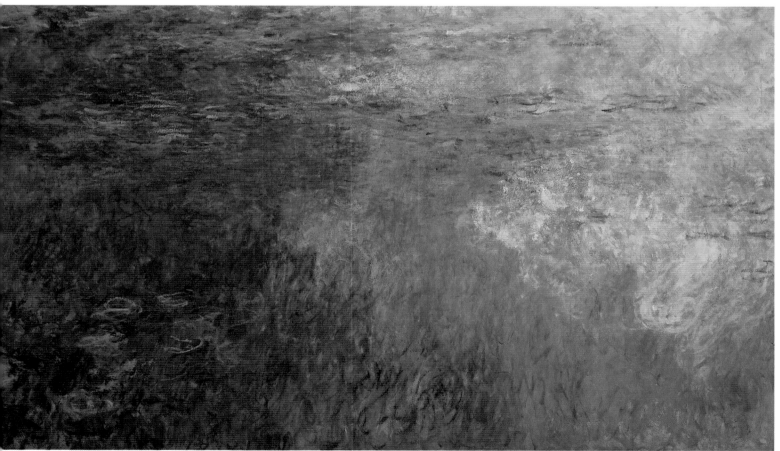

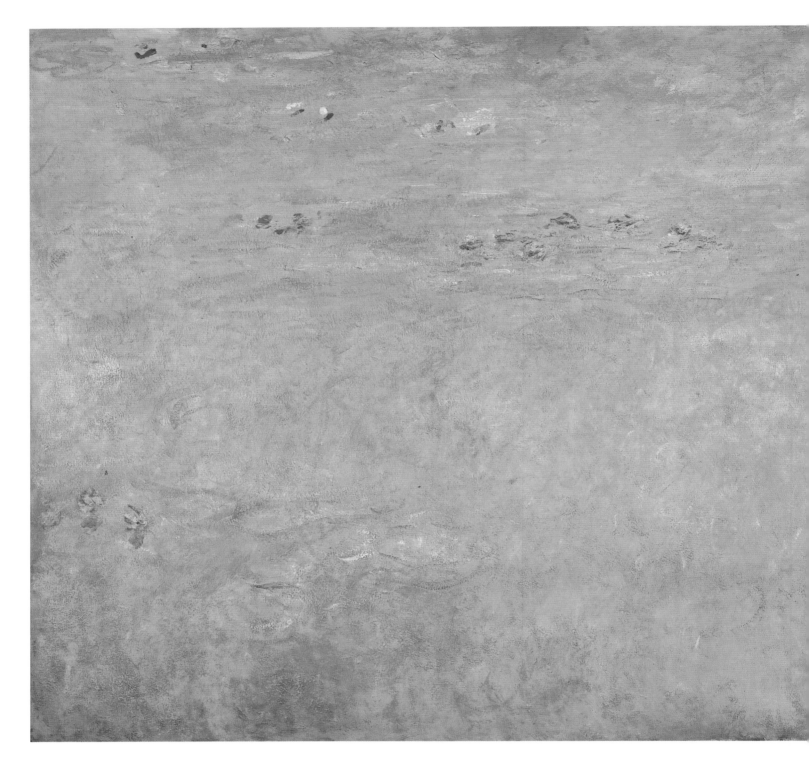

Waterlilies, 1916
Oil on canvas, 78¾×168 inches (200.7×426.7 cm)
The National Gallery. London

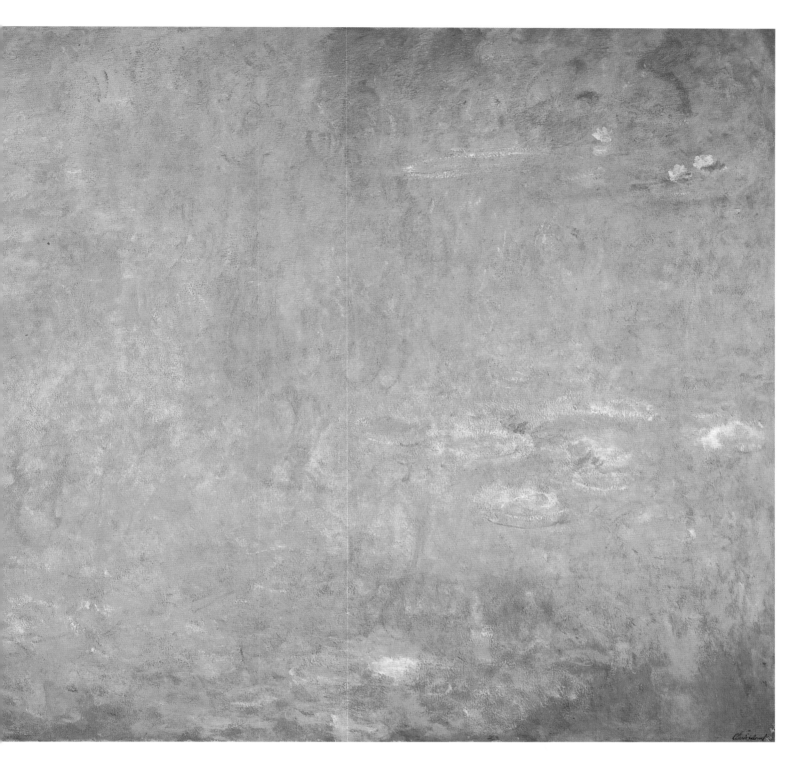

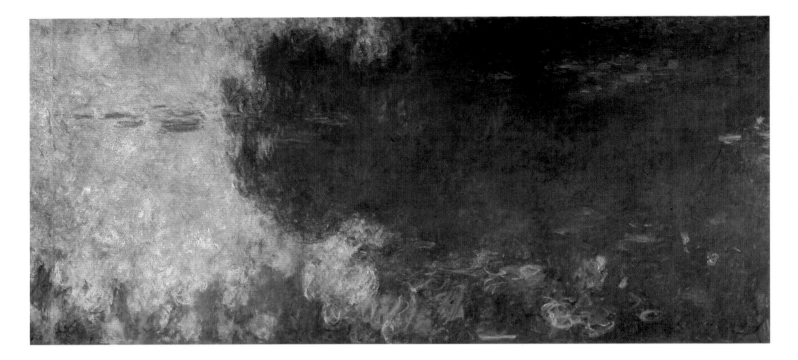

ABOVE
Weeping Willow, Morning Effect (detail), 1914-18
Oil on canvas, 78¾×167½ inches (200×425 cm)
Musée de l'Orangerie, Paris

RIGHT
Green Reflexion (detail), *c.*1916-26
Oil on canvas, 78¾×335 inches (200×850 cm)
Musée de l'Orangerie, Paris

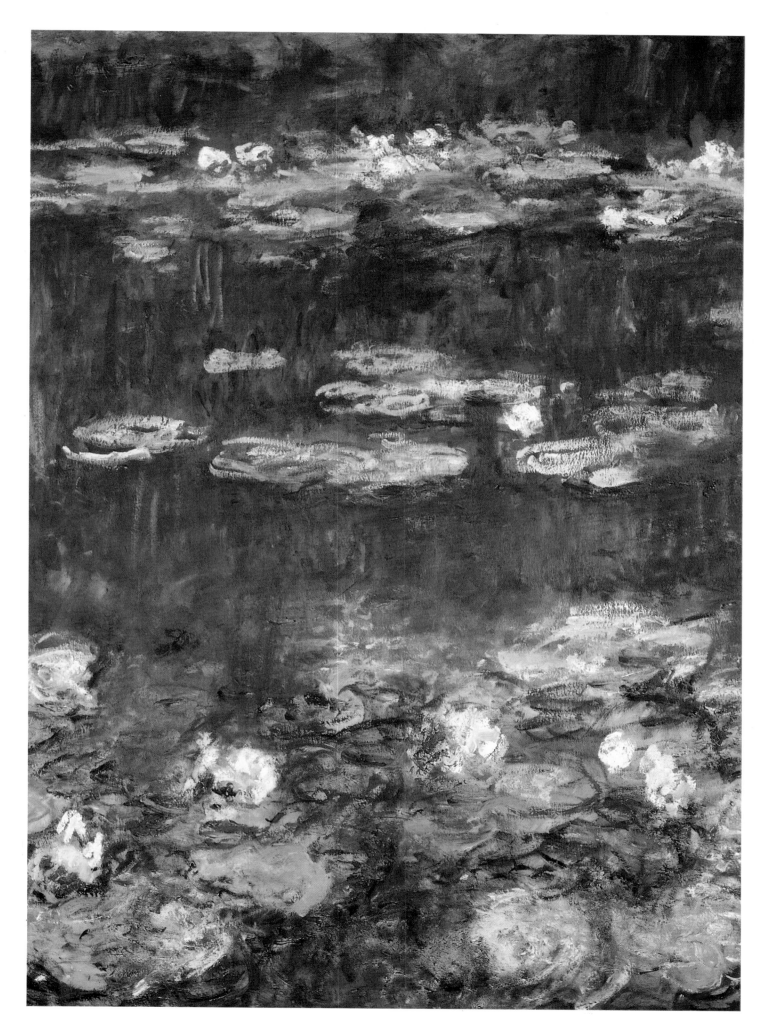

ACKNOWLEDGMENTS

The publisher wishes to thank Martin Bristow, who designed this book; Jessica Hodge, the editor; and the following institutions and agencies for permission to reproduce illustrative material.

Allen Memorial Art Museum, Oberlin, Ohio: page 29

Art Institute of Chicago: pages 34, 37, 66-67

Calouste Gulbenkian Museum, Lisbon: pages 58-59

Cleveland Museum of Art, Ohio: page 39

Collection Durand-Ruel, Paris: page 90

Courtauld Institute Galleries, London: page 70

Dallas Museum of Art, Texas: pages 56-57

Detroit Institute of Arts: pages 84-85

Eknayen Collection, Paris: page 24

Fitzwilliam Museum, Cambridge, England: pages 62-63, 108

Fogg Art Museum, Cambridge, Massachusetts: page 43

J Paul Getty Museum, Malibu, Florida: page 51

Haags Gemeentemuseum, The Hague: page 32

Hermitage Museum, St Petersburg/photo Scala, Florence: page 26

Kimbell Art Museum, Fort Worth, Texas: page 21

Kunsthalle, Bremen: page 27

Kunsthalle, Hamburg: page 97

Kunsthaus, Zurich: page 93

Metropolitan Museum of Art, New York: pages 22, 30, 48, 98, 109

Musée d'Art et d'Histoire, Neuchâtel: page 79

Musée des Beaux-Arts, Caen: pages 1, 119

Musée Eugène Boudin, Honfleur: pages 7 (top), 99

Musée du Louvre/photo Réunion des musées nationaux: page 82

Musée Marmottan, Paris/photo Routhier: pages 9, 68-69, 80-81, 89, 103, 115, 122

Musée de l'Orangerie: pages 123, 126, 127

Musée d'Orsay, Paris/photo Réunion des musées nationaux: pages 8 (below), 9 (top), 18, 19, 28, 38, 40, 44, 47, 49, 52-53, 64-65, 74-75, 76, 78, 86, 87, 91, 95, 101, 111

Musée d'Unterlinden, Colmar: page 104

Museum of Fine Arts, Boston: pages 20, 83, 102, 105, 207, 112, 120-121

Nasjonalgalleriet, Oslo: page 100

The National Gallery, London, reproduced by courtesy of the Trustees: pages 6, 46, 50, 54-55, 118-119, 124-125

National Gallery of Art, Washington: pages 31, 77, 96

National Gallery of Ireland, Dublin: page 71

National Gallery of Scotland, Edinburgh: pages 106, 110

National Gallery of Wales, Cardiff: pages 2, 113

Nelson-Atkins Museum of Art, Kansas: page 73

Niedersächsisches Landesmuseum, Hanover: page 88

Ordrupgaard Collection, Copenhagen: page 23

Osterreichische Galerie, Vienna: page 117

Private Collection: pages 114, 116

Pushkin Museum, Moscow/photo Scala, Florence: pages 15, 72

Shelburne Museum, Shelburne, Vermont: page 92

Städelsches Kunstinstitut, Frankfurt: page 35

Wadsworth Atheneum, Hartford, Connecticut: page 10

Walsall Art Gallery, England: page 94

Walters Art Gallery, Baltimore: pages 60-61